A Guide to Creating Dog Portraits

A Guide
to Creating
Dog Portraits

Kim Styles

NEW
HOLLAND

First published in 2015 by New Holland Publishers Pty Ltd
London • Sydney • Auckland

The Chandlery Unit 009 50 Westminster Bridge Road London
SE1 7QY United Kingdom
Unit 1 66 Gibbes Street Chatswood NSW 2067 Australia
218 Lake Road Northcote Auckland New Zealand

www.newhollandpublishers.com

A record of this book is held at the British Library and the
National Library of Australia.

ISBN 9781742575780

Managing Director: Fiona Schultz
Publisher: Alan Whiticker
Editor: Simona Hill
Designer: Andrew Davies
Photographs: Kim Styles
Production Director: Olga Dementiev
Printer: Toppan Leefung Printing Ltd (China)

10 9 8 7 6 5 4 3 2 1

Our thanks to: Corbis, for the image on page 10.

Keep up with New Holland Publishers on Facebook
www.facebook.com/NewHollandPublishers

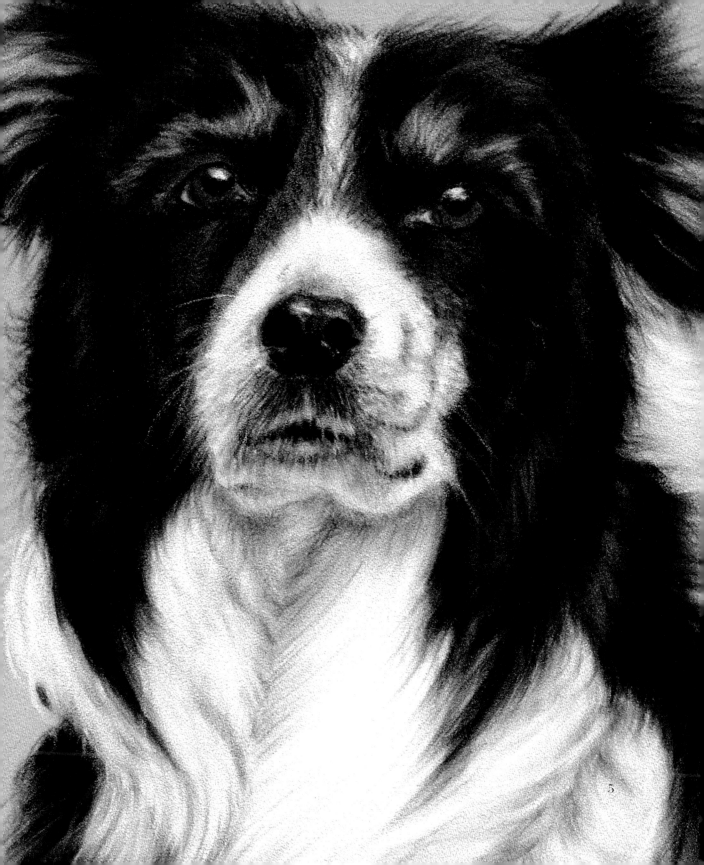

Contents

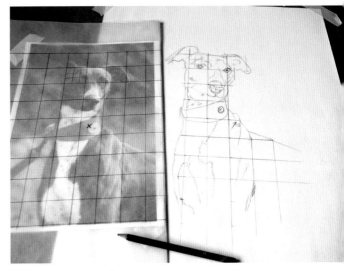

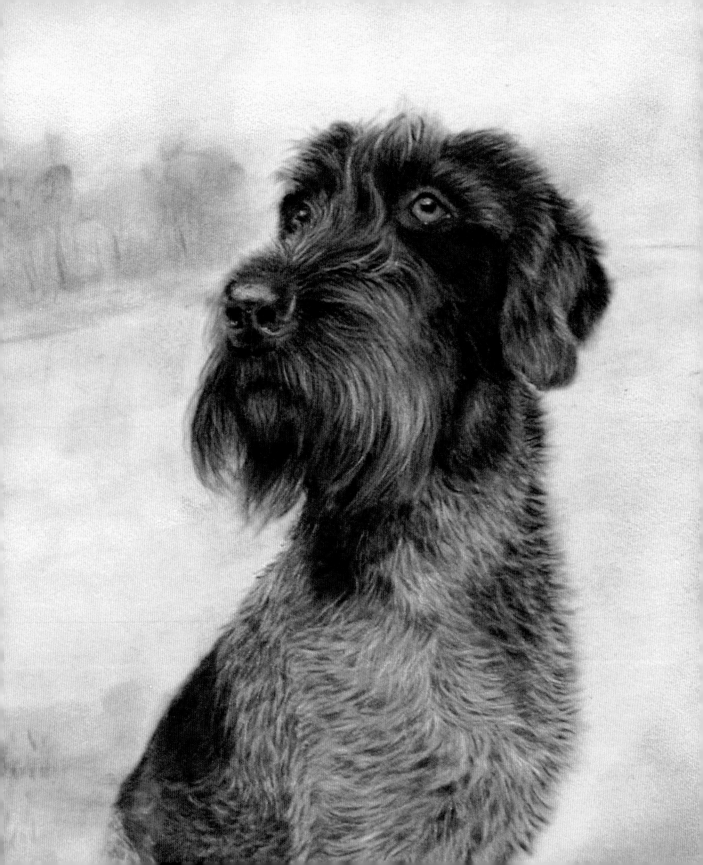

Introduction

I was raised amid beautiful countryside in England and from an early age I learned to love animals and appreciate nature. At school I discovered that I had a talent for art, so I honed my creative abilities, and later went on to study Art and Design as well as Art History. From there, I began creating pet portraits and turned this skill into my profession.

People often ask, when they see my paintings, how I do it. In this book, I show you how. This is not an instruction book though, that tells you to do this and add that. Instead, it's a guide in which I show how I approach different techniques and in describing what I do, I hope to inspire you to try your hand at creating your own pet portrait. It doesn't matter if you've never picked up a pencil in your life, or indeed, if you are a budding artist in need of a confidence boost and a little more insight. I believe that anyone can produce a beautiful picture of their animal with practice and guidance, and I will show that

it is ok to make mistakes along the way. By demonstrating different methods of creating a 'first' sketch, I will show you that there is no right or wrong way to go about making a portrait. I will describe and illustrate the techniques that I use, and take you through to a finished piece in a step-by-step format, including rectifying mistakes as I work.

The techniques that I use can readily be applied to any other piece of illustration – it just happens that I choose to portray canines. The techniques that I use include freehand drawing, using a grid as a guide to create a drawing, and a method of tracing from a reference picture.

Visit my website www.kimspetportraits. com or find me on Facebook at Kim Styles Pet Portrait Gallery if you would like to take a look at more of my finished works.

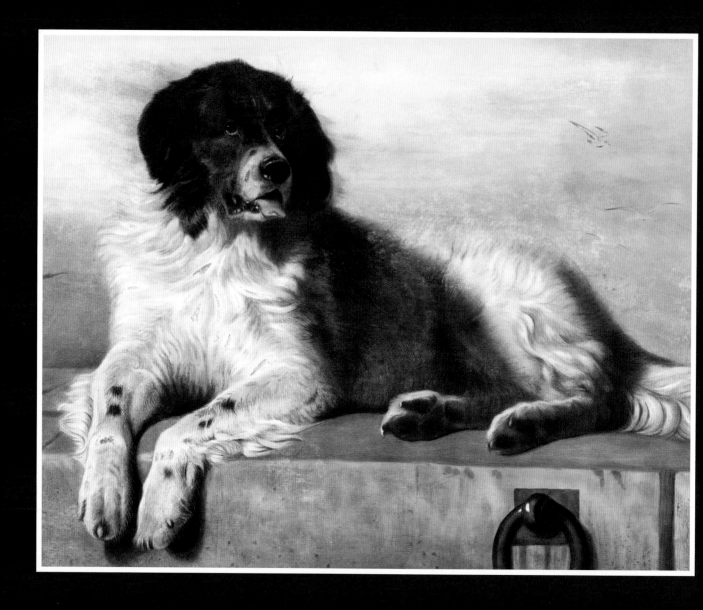

A Brief History of Dogs in Art

Some of the earliest portrayals of dogs were found in caves, which are believed to have dated as far back as BC4,500.

More stylised drawings were created by the ancient Greeks, Egyptians and Romans. There are ancient Greek vases in museums today that depict hunters and horse riders with their dogs that date from around BC 500.

Toward the Middle Ages dogs were more widely portrayed in art, especially in hunting scenes. By the 18th century, canine art had became ever more popular. The paintings of this era reflect the fact that people kept dogs for companionship as well as for working and hunting. Sir Edwin Landseer (1802–73), best known for his sculptures of the lions at the base of Nelson's Column, in London's Trafalgar Square, was a well-known portrait artist during the 1800s and was commissioned to paint pets and working dogs for royalty as well as the wealthy classes.

By the mid 19th century, dogs were becoming more highly bred, with each breed associated with specific skills and qualities including working, farming, gun dogs, guarding, or as companions. The formation of the Kennel Club, to define each breed's characteristics led to a surge in popularity of animal portraiture. Nowadays pet portraits are affordable art for those who wish to commission an artist, and modern materials such as pastels and quick-drying acrylics mean they can be made quickly. The digital age and social media have made it possible for artists to come together in specially formed groups and swap ideas and experiences as well as share their art.

Tools and Materials

Pastels

A pastel painting that is created using top quality pastels can last for hundreds of years. Pastels are made from exactly the same type of pigment that is used to make oil paints. They have a rich intensity of colour and can be blended to achieve different hues. Pastels are sold as sticks or blocks in different sizes and types, including oil pastels and chalk pastels. Oil pastels produce a waxy surface and lend themselves to landscapes, abstracts and still life paintings. For portraiture, I use chalk pastels, which give a portrait a lovely soft feel and can produce an almost three-dimensional effect. There are thousands of colours to choose from so I would recommend you choose a boxed set to begin with, and buy new colours as separate sticks to add to your collection as the need arises. A box of 12 sketching hard pastels with a few additional sticks in varying hues of grey are sufficient for a beginner's first attempt.

I use a mixture of soft (round and square) and hard (square) pastels. There are many different brands available so what you choose really is a matter of trial and personal preference. For my pieces I would choose a boxed selection of hard pastels in a 'grey selection' and the same number in a 'sketching selection' that incorporates different colours. Hard pastel sticks are good for both blocking in large tones by using the flat side of the pastel and also for achieving detail by using the edges. I also have a box of soft pastels in a selection of colours, though I could actually manage without them. I find them handy for blocking in large areas of colour or tone, and I use them often for background work.

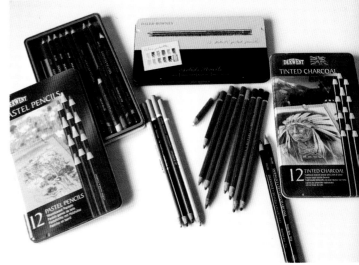

Pastel Paints

Pastel paints are available in student quality and artist quality. I would suggest that you buy the best quality that you can afford. Artist quality is the most superior that you can buy and they last a surprisingly long time.

Pastel Pencils

Alongside the pastel paints, I use Daler Rowney and Derwent pastel pencils. Both of these brands have a decent selection of different colours, though other brands are available that you might like to try. The black and the white pencils are the ones that I use most, though I also use a lot of brown, orange and grey shades.

I also use charcoal pencils occasionally though these are not essential. I find pastel pencils make a much smoother mark than the charcoal pencils, but that the charcoals are good for producing scratchy marks and other interesting textures.

As you gain more experience of techniques and test out different brands, you will develop your own preferences. There aren't any rules – just use whatever suits you best.

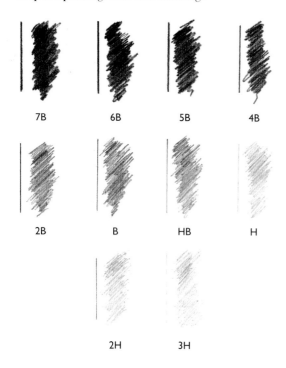

7B 6B 5B 4B

2B B HB H

2H 3H

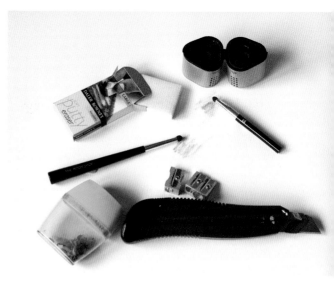

Graphite Pencils

I often use graphite pencils in my portraits if I want to apply some minute details, or if I want to experiment when creating different types of fur. I also use pencils for sketching and creating background grids.

Pencils are graded from 'H' (Hard) to 'B' (Black) with a numerical scale. The scale goes from 9H through to 9B. In the picture above you can see the marks I have made with various pencils. 3H is the lightest mark I have made and 7B is the darkest. All of these marks were made using a light to medium pressure. Middle of the range is HB,

which is traditionally a writing pencil. 'H' pencils tend to be used for technical drawing or writing, while the 'B' pencils are best for sketching and shading. If you don't want to buy a whole set of pencils then a 5B or 6B is useful for sketching, and a 2H is perfectly adequate for line drawing. I like the 2B pencil. It's a good all rounder and I use it for most of my sketching.

Sharpeners and Putty Eraser

A kneadable putty eraser is a good thing to have in your collection in case you want to 'lift' a little colour off the paper so that you can correct errors. I find that I use my putty eraser when producing initial rough sketches on inexpensive paper. I've used it when I've incorrectly drawn a grid.

A good quality sharpener such as the small metal variety, available in art shops, is good and convenient, though a good quality craft knife is just as good to get a good sharp point on a pencil. I tend to sharpen

pastel pencils first with a standard pencil sharpener and then I hone the point with my craft knife. If you're lucky enough to know someone who has access to a bench grinder this is an excellent way to get a good sharp point, but I would only recommend this if you are considering becoming a full-time artist and your pencils are going to be used constantly. A piece of sandpaper (glasspaper) can be handy for achieving a really fine point on a pencil. You can buy sandpaper blocks from most art supply stores and they are relatively inexpensive though a sheet of standard sandpaper will work too.

Blending Tools

Specialist blending tools are available for purchase in art shops though I don't use them. Before I knew of their existence, I used my fingers to blend colours or any other suitable item that I could find around the house. Cosmetic blending sticks, which have a small piece of foam attached to one or both ends, are available from make up counters and pharmacies, are inexpensive and last a long time, so I often use these. I find they blend colours beautifully without being too harsh. Hold the blending stick as you would a pencil and just move it over your colours in the direction of the fur. In the past I have used make up sponges, cotton buds and fine paintbrushes for blending too.

Rule

I use a rule occasionally for measuring details on a portrait, for example, if I need to know that I have sketched the ears of my subject the correct distance apart. Other than this I would use a rule if I decide to make a grid before I draw my initial sketch. I use the grid method if I constantly keep getting my initial sketch wrong. An inexpensive 30 cm (12 in) rule is fine.

Fixative

This is supplied as a spray in a can and is available from art shops. It fixes pastel colour to the background paper when the illustration is complete and prevents the finished piece from smudging. I use hairspray instead of fixative because it is much cheaper and works just as well. I have been told that hairspray causes 'yellowing', but I've never found it to cause any more of a problem than the more expensive and proper fixative.

Masking Tape and Easel or Board

Any work surface is sufficient to work at as long as it's smooth and solid. You may be lucky enough to have an easel. If not, you can just as well use the kitchen table or a wooden board. Use masking tape to fix the paper to the background surface so that it doesn't slip every time you make a mark. Masking tape is also very handy for removing pet hairs and dust from your paper. While I am working on my portraits I also tape a small scrap of paper to the side of my work. This is to scribble on and to check the kind of mark, or shade, my chosen pastel or pencil will make.

Pastel Papers

There are many types of paper that are suitable to draw on using pastels. What you use is a matter of personal choice. Your choice of paper may be determined by how light or heavy handed you wish to be when you draw or paint and the finished style you wish to achieve. The three main things to consider are the texture of the paper – how smooth or rough it is, the colour of the paper, and the weight. The texture, or the grain, can vary from a very light textured surface to a much coarser grain and something that almost resembles sandpaper. If you wish to produce your dog portrait in a realistic style then a very heavily textured surface would be quite difficult to work on because you will find yourself fighting against the grain when you are trying to apply details. However, if you want to produce a much 'looser' portrait then this type of paper can be ideal.

The reason that pastel paper has a grain is so that the pigment that is applied is actually 'grabbed' by the tooth of the grain. If you try sketching with a pastel stick across very smooth paper you would find it might make hardly any impression.

I would suggest that a good quality pastel paper is always the best choice. I often use cheaper paper to practise my early sketches and then use the more expensive paper for my actual portrait. I also recommend using 'acid free' paper to avoid it yellowing in the future.

Velour paper is an alternative paper that you could try. This paper has a soft velvety side and, although it doesn't really allow the use of an eraser, I find it to be ideal for helping me to achieve a soft, smooth, and realistic finish. For me, the advantages of the soft, dream-like images that can be produced on velour far outweigh the fact that I cannot use an eraser. I also find that velour paper grabs colour instantly and you retain control of the density of colour that you apply. In addition, velour paper accepts many layers of pastel and pencil colours and if I make a small colour error I can brush a layer off with a stiff paintbrush, or simply go over the layer with a different colour.

Pastel papers come in every colour and shade you could imagine from pure white through to black. I generally choose neutral, or slightly tinted, coloured paper, which makes it easier to identify different light, dark and medium tones. I generally buy an 'off-white' or 'light grey' paper for that reason. You could always paint a background in if you wish.

Try experimenting on samples of different papers. You should be able to pick some up at your local art shop for free. I have used quite smooth paper for portraits but after a while have found that my fingers become sore due to vigorous rubbing in.

In the photograph on the left, overleaf, I show three applications on slightly grained sketchbook paper. The marks on the left are achieved by rubbing the side of the pastel on to the paper. This is known as scumbling. The central marks are the same application but I have rubbed the colour into the paper with my fingers. The right-hand markings are the same as those in the centre, but this time I have added small sweeping lines

using the corner of a square hard pastel, to demonstrate how fur can be suggested. This is known as feathering.

In the photograph on the right, overleaf, I have made the same application as before, this time on velour paper. The markings now have a softness that looks almost blurred. I've scumbled the left-hand marks, which when compared with the marks on the previous paper, show a much more solid mark. To the centre column I have added a few feather strokes with a hard pastel stick. In the right-hand column I have used a pastel pencil. To the bottom of the right-hand mark I have also added a few tiny white marks where the 'feathers' bend. These marks indicate where the light bounces off the fur.

Vang pastellmalblock velour paper is my favourite paper and it is available in many colours and sizes. It can be bought as a handy 10-sheet book and is convenient to store away when not in use. I buy it on the internet as it is not readily available in my local art shop. It is relatively expensive, though, so I would recommend shopping around or buying single sheets to begin with. The weight of velour paper is not quite as important when using pastels as it would be if I were using watercolours, acrylics or oils. This is because 'wet' paints affect the paper differently. Lightweight paper needs to be stretched if it is to receive a wet medium. (The weight of the paper refers to its thickness. Pastel paper varies from 90 gsm (grams per square metres) to around 180 gsm. The velour paper pictured is 180 gsm.)

The weight of velour paper will, however, affect how heavy-handed you can be with your application of pastel colours. The heavier the paper the more you have the freedom to be heavy handed. If I make a mistake I simply cover it up. I have yet to produce a painting or picture that doesn't have a mistake in it!

Windsor and Newton Heavyweight sketchbook paper.
For pencil, pan and ink and watercolour.
Acid free 170 gsm.

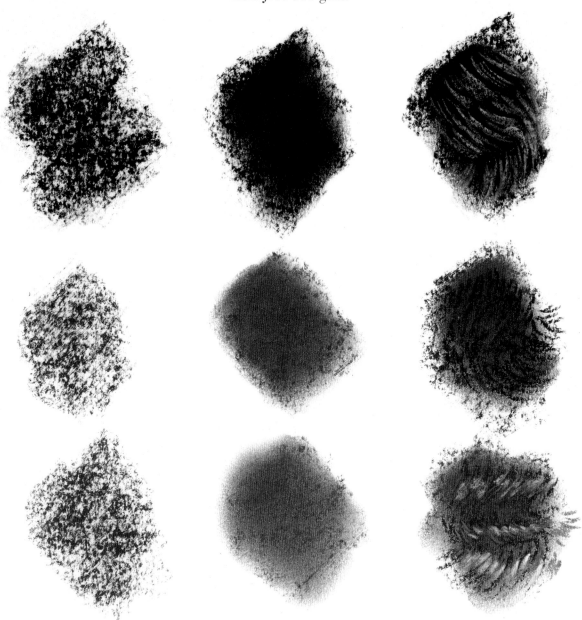

Vang Pastellmalblock
Velour paper, 180 gsm.

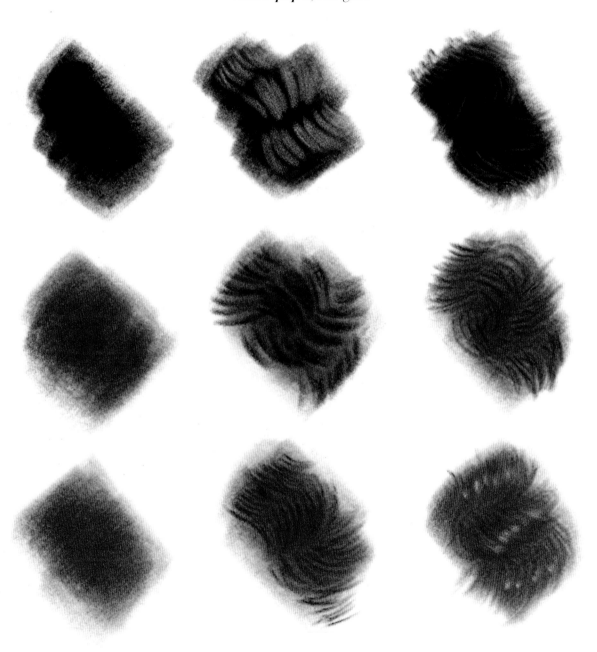

Observation

This is by far the most important skill that you will ever need. Teach yourself to observe. Begin by looking at everything around you with renewed vigour. Look at a clump of trees, for example. What colours would you need on your palette to paint them? Obviously a few different shades of greens, but if you look again, how many more colours and shades can you see? Where are the darkest parts? Which way is the sun shining on them? Where are the brightest parts?

Look at a view with a distance. Not necessarily outdoors – you can do this on the television, or a photograph in a book, if you wish. What do you notice about the colours of, say, hills far in the distance when compared to the colours nearer to you?

Look at clouds, they are certainly not white. Look at the shadows on a path, they're not black either. Look again. Study an object placed near a window indoors. Look for the different tones and shades created by the way the light falls on to it.

Watching television is a great way to observe colours and how light affects them. Look at a person's face on the television. Notice that the objects around them throw colours and shades back at them. For example, notice the man wearing a purple (red, green, yellow – whatever) shirt. Look how that colour reflects back on to his skin. Notice how it changes as he moves and as the objects and the light around him changes.

Now that I've trained myself to 'observe' it has become second nature and I constantly observe everything while I'm watching television, walking the dog in the fields, sitting in waiting rooms, in cafes, on the bus, plane or train.

The picture on the right shows a detail of a fairly long-haired dog's fur. You can see instantly that it belongs to a black dog. Now look again at the picture and notice how much 'black' is actually in there. There's hardly any... Keep looking at it and try to work out just how many colours are in there.

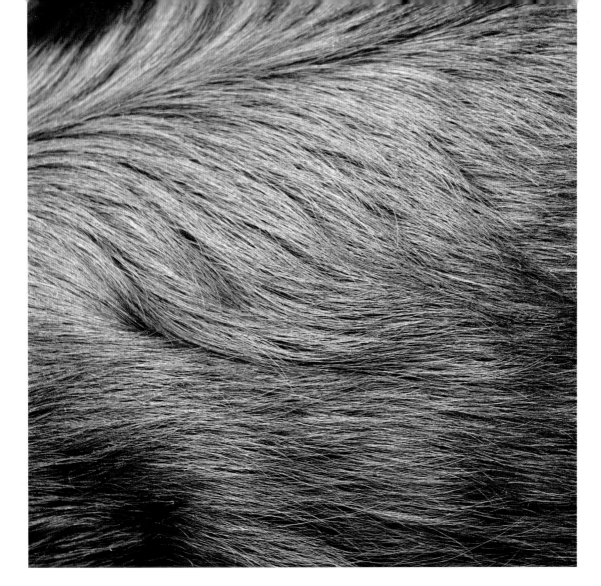

I can see blue, purple, grey, white and black.

Study your pet. Observe its fur. Work out where the light is coming from and where the shadows are. What colours are being thrown onto your pet by nearby objects? There may not be any. Get up close. Observe in which direction the fur grows on your animal's face. Notice the different directions of the fur around the face and body. Study the shadows in between the hair/fur and then study the fur itself and notice where the lighter parts are – where the light reflects off the strands of fur.

Observation is what a natural artist does instinctively, but it is something that can be learnt. Hopefully, by the time that you have read through this book, you will looking anew at familiar views and the objects that surround you.

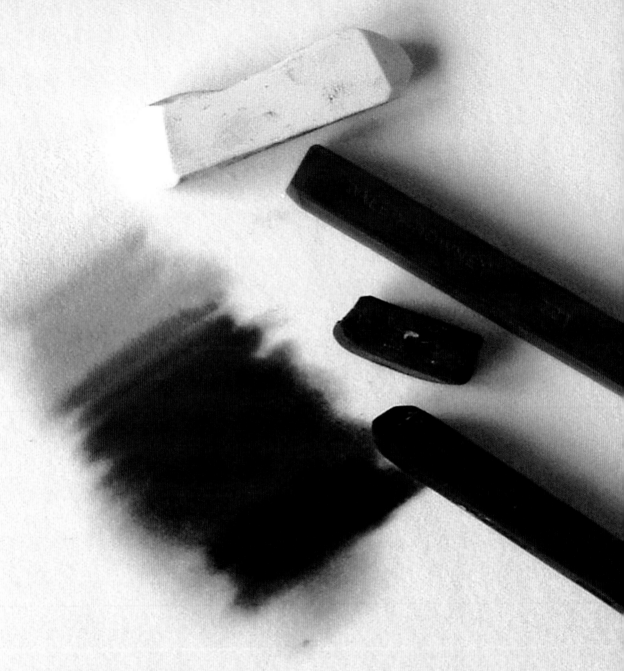

*"Creativity is allowing yourself to make mistakes.
Art is knowing which ones to keep."*

– SCOTT ADAMS

Colours –
A Brief Explanation

If you already have an interest in creating art then you probably know the basics of colours. The primary colours are yellow, red and blue – and these can be mixed to achieve almost any other colour. For example; Yellow mixed with blue creates green, yellow with red creates orange, and red and blue create purple. Green, orange and purple are known as secondary colours. You can go on to produce further colours by mixing primary colours with secondary colours, such as yellow mixed with (secondary) green would produce yellow green. Mix the three primary colours together and you will have a brown. Add to that the uses of black, white or grey to darken or lighten the colours then you begin to see how infinite this is. There is also the matter of cool and warm colours. Warm colours are usually reds, yellows and oranges whereas cool colours are blues, greens and purples. If you were to select a grey, for instance, it would be a cool grey if it had a blue base but it would be warm if it had a red base. You can see this in the picture of

pastel markings on paper. The list is endless and the more you begin to learn about colour, the deeper the subject becomes.

I would advise you to experiment with any paints or pastels to spend some time just mixing different colours on to a spare sheet of paper. Absolutely every colour/shade is available on the high street these days, but if you want to limit the amount of colours that you buy, then start with the primary colours, and black and white, and maybe build up with more colours as you add to your collection.

I find my palette is naturally limited to a few colours depending on the type and colour of dog, but I also use small amounts of colours in the dog's fur that you wouldn't always expect. If I'm creating a brown Labrador, for example, I imagine how it would look in the sunshine and may add the tiniest bit of red or orange where the sunlight reflects. On a pure black dog I might add a touch of ultramarine blue to really bring the blackness out. If it's a white dog I tend to

23

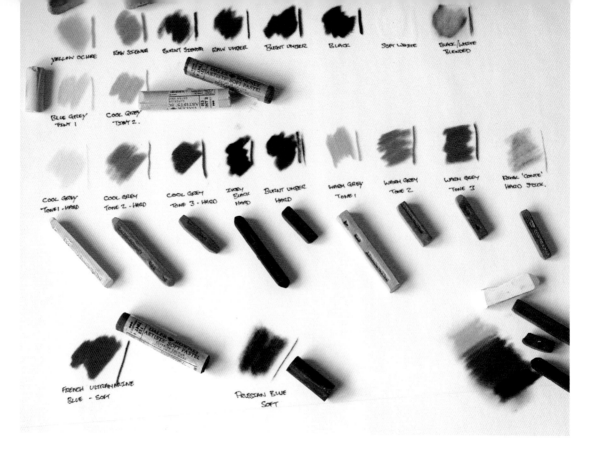

Pictured are some examples of the colours I use. From top left: yellow ochre, raw sienna, burnt sienna, raw umber, burnt umber, black, soft white, black and white blended. Blue grey tint 1, cool grey tint 2. Cool grey tone 1 hard, cool grey tone 2 hard, cool grey tone 3 hard, ivory black hard, burnt umber hard, warm grey tone 1, warm grey tone 2, warm grey tone 3, royal 'Conte' hard stick. French ultramarine blue – soft, Prussian blue soft.

use either soft browns or soft blues for the shadows. I experiment as I work since, for me, colour is very instinctive, but I will aim to show this within the examples in the book.

Pictured are some examples of the colours I use. From top left: yellow ochre, raw sienna, burnt sienna, raw umber, burnt umber, black, soft white, black and white blended, cool grey, blue grey – all soft pastels. Next are the hard pastel sticks: Cool grey shades, Burnt umber, warm grey shades, a vibrant pink 'Conte' stick and the two blues, ultramarine and Prussian.

The marks made with soft pastels are very similar to the marks made with the hard pastels. You don't need both. If I had to choose, I would select the hard pastels because I find them to be more versatile.

When it comes to applying smaller marks and details, such as fur or whiskers, I can use the edges of the pastels to create sharper lines. I use the sides of the pastel stick to make broader marks.

Try to imagine that when you put one colour next to another it begins to tell a story. A streak of black, for example, is a streak of black. If you put a block of white in the centre it becomes something else. Maybe a strip of black leather with the light bouncing off it? If you add a touch of yellow it could become a strip of black leather in the sunshine. The colours you select to put next to each other make a difference to the final work. If you were to use too many colours in one area you may end up with a muddy appearance.

Soft Pastels

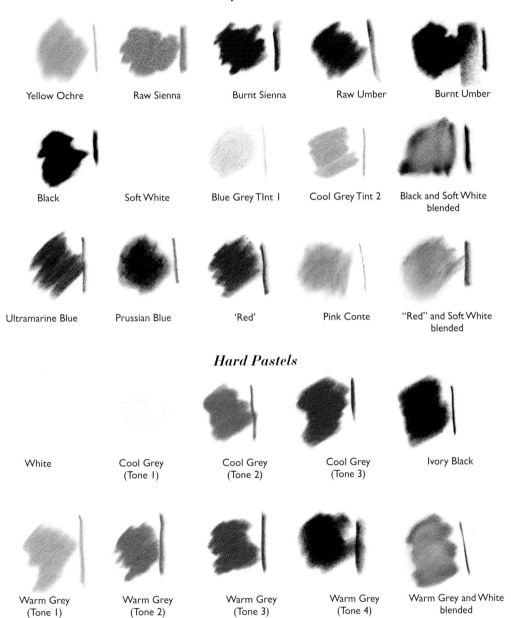

Yellow Ochre

Raw Sienna

Burnt Sienna

Raw Umber

Burnt Umber

Black

Soft White

Blue Grey TInt 1

Cool Grey Tint 2

Black and Soft White
blended

Ultramarine Blue

Prussian Blue

'Red'

Pink Conte

"Red" and Soft White
blended

Hard Pastels

White

Cool Grey
(Tone 1)

Cool Grey
(Tone 2)

Cool Grey
(Tone 3)

Ivory Black

Warm Grey
(Tone 1)

Warm Grey
(Tone 2)

Warm Grey
(Tone 3)

Warm Grey
(Tone 4)

Warm Grey and White
blended

How to Photograph Dogs

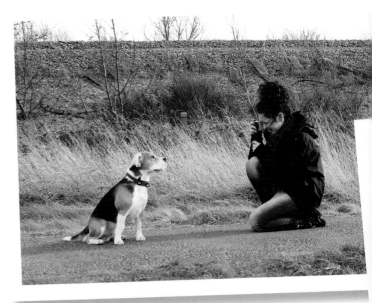

Many dogs don't enjoy having their photograph taken. It only takes five minutes or so of pointing a strange object at your subject before boredom on their part sets in. There will always be exceptions, though, so if you have a pet that will pose at your command then you are very lucky. If the dog that you want to photograph is particularly energetic, or excitable, then you could consider tiring him out by playing with him for a while or taking him for a long walk before the photoshoot begins. To help your subject appear to be looking toward the camera, and to help strike a good pose, get the dog to sit. You, as the photographer, need to get down to the dog's level so that you can shoot the picture straight on. A second person, preferably the dog's owner, should ideally stand behind the photographer while holding a treat or a favourite toy. Hopefully, while under instruction to 'stay' the dog will gaze lovingly at the treat or toy long enough for you to get a few snaps that shows his real personality.

You need good light to take a good picture so if you can work outside then do so. If taking the picture outside is not an option then try to place the dog next to a window or in a conservatory. Never use a flash indoors as it will bounce light back off the subject and distort its true colouring. Try to avoid strong sunlight, if possible, and make sure that nothing is casting a shadow over part, or all, of the subject. The midday sun can be harsh on a very hot day. On very sunny days it's probably best to take photographs during early morning or late afternoon. Some lovely effects and tones can be achieved during this time of day.

Position yourself on the ground at the dog's level or raise the dog up to your level. You could place him or her on a bench, patio table, chair or something similar. Of course, this works better with small dogs.

A lot of people make the mistake of standing over the dog and taking a shot while it is looking up at them. This photograph of a Labrador has been taken

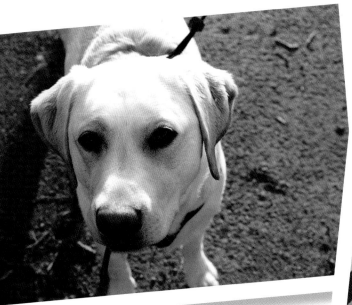

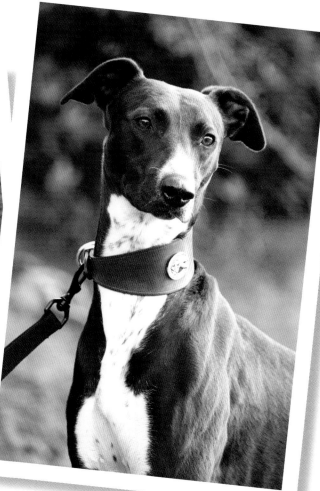

by pointing the camera down at her. As you can see it is not ideal to try to compose a portrait from it because the dog's head is nearer to the camera so it looks larger and out of proportion with the rest of her body. Also it was taken in the shade so it doesn't really bring out the colours and tonal values very well.

Get as near, and down, to the subject as you can so that most of your 'frame' is filled with the dog's face and chest. If you are aiming to get the full dog in the frame then move further away or zoom out.

Above right is a perfect photographic portrait of a Lurcher. It was taken by a professional photographer who has captured the detail, light and form beautifully. The photographer has taken her subject to a local

beauty spot to be able to find an appealing backdrop. She has considered the posture by making the dog sit on a rock, so that she is at the same level, and she has taken into account the sunlight filtered through the trees above to achieve a good balance of light and shadow. She took around a dozen shots from different angles until she was happy with the result. Take as many photographs as possible and, hopefully, you will have at least one good shot.

27

Composition Challenges

"Great things are done by a series of small things brought together."

– VINCENT VAN GOGH

Composition is how you put various parts of something, in this case one or more dogs, together in relation to the space you have (in this case the size of your paper) to achieve a portrait that is balanced and aesthetically pleasing.

Think about how you will position your subject and consider the size of the subject in relation to your paper size. Work out how the area and space around your drawing to the edges of your finished piece will look. A lot can be said for using your instinct. Prepare a quick rough sketch on inexpensive paper and you'll soon get a feel for when something looks 'right'. Sometimes (if you're lucky) you will get a photograph that has, more or less, done the composing for you.

I composed the image above from two separate photographs. Often, if I am asked to portray two or more animals I will usually place them together, slightly overlapping because it gives the finished piece a coherent look rather than a portrait of two separate and unconnected dogs 'floating' on the paper. I have also placed them on different levels and this makes it easier for the eye to be drawn in to both of them. Harmonious composition is essential for a serious piece of art. You also need to be aware of the relative sizes of the dogs if they're from different photographs. One small dog may have been taken close up and a large dog from far away, which will make the sizes out of context. Sometimes a little educated guesswork is needed.

On the right-hand page is Bess. Her owner loaned me a photograph album full of photographs of her from being a puppy right through to her twilight years. She asked me for five images on one portrait, from young to old, to portray her long life. Bessie's owner also chose her favourite photograph for the larger image in the centre. As you can see from this finished portrait I have overlapped all of the different images. This is to convey a sense of a story about her life, rather than having the viewer feel uneasy because their eyes are trying to make sense of a disjointed

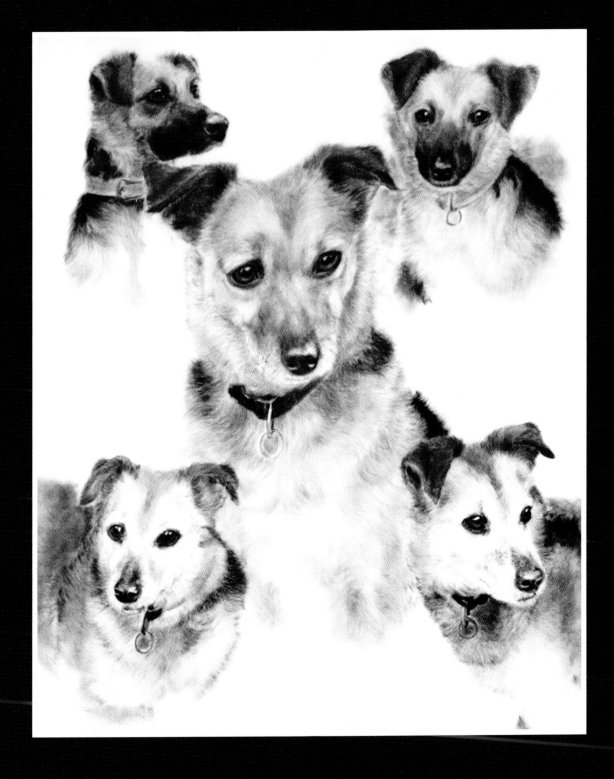

set of separate pictures.
I hope that the viewer can initially accept
the painting as a 'whole' and then enjoy
the different images of Bess at their leisure.
Composition is essentially something that has
been created by arranging several 'things' to
achieve a unified whole.

Above is a pedigree German Wirehaired
Pointer. His owner wanted a painting of him
that depicted his handsome head and chest
in close up but also an image of him working
in the field (pointing). I had about a dozen
photographs of him to choose from.

Initially, I created a very rough sketch
to position both images. I placed his head
and chest on the right-hand side of the
composition and his (smaller) working
image on the left! At first it looked a little
disjointed so I brought them closer together
and then added a suggestion of a distant

background to bring
it all together as a whole. I sketched
a smaller different pose and moved them
even nearer to each other and I then chose a
slightly different pose of the head and chest
shot. I wouldn't 'overlap' these images for
this particular composition because it was to
be a painting of two different scenarios – one
in which the dog is out in the fields working
and the other is a 'bust' portrait. I placed a
sloping horizontal eye line diagonally across
the centre and suggested trees, hills and sky.
This would bring it all together as you can
see in the finished piece.

Composing multiple images, especially
if they're different poses, or scenarios, are
probably the most challenging compositions
to do.

30

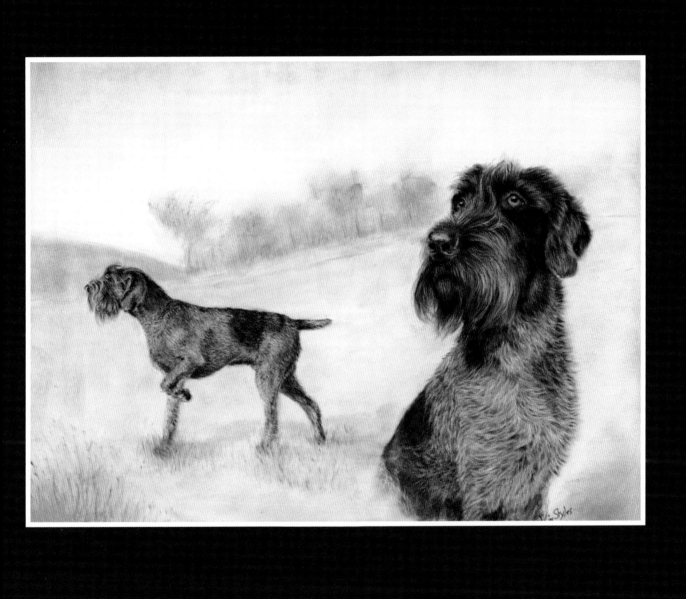

Eyes and Noses
and Other Details

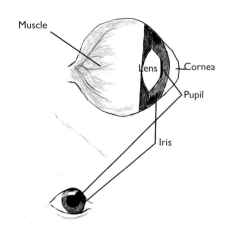

Eyes

Dogs' eyes are very similar to those of humans. Mostly oval or round, dog's eyes have the same anatomical attributes as a human eye. From an artist's point of view it is good to know the basics so that we know why we are drawing certain things. I initially work out exactly where to place the eyes, which I will demonstrate further on in more detail on a 'real' dog, and then I draw the outer shape, whether it be round or oval, and then I place the iris (the circular coloured part of the eye) followed by the black pupil and tiny reflection. The cornea on the outer edge of the eye, as shown in the diagram, is a clear film that protects the eyes from dust and particles. Because the cornea is curved and clear it causes a small reflection when light bounces off it. This is why you see a 'white' fleck, which is a tiny reflection, within the eye (pupil area), in almost any good photograph or portrait of any animal. A good tip when drawing a dog's eyes is to try to not show too much of the white area around the outside of the iris. When a dog is showing this it generally means it is uneasy or looking for reassurance. It is called 'whale eye'. Another tip is that when you apply the reflective 'fleck' in the eye think about other things in the reflection, like the sky. I sometimes add a minute touch of blue to the fleck and this can really bring the eyes in to a more realistic finish. I will show this further on in the book.

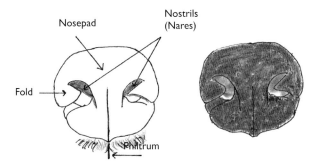

Fig. 1 – Anatomy *Fig. 2 – Colour* *Fig. 3 – Shadows* *Fig. 4 – Highlights*

Noses

Dogs' noses are not similar to ours in certain aspects but within all of the shapes, sizes and colours of different dogs they do have basic similarities. Dogs' noses have two nostrils, which are not quite shaped like human nostrils. They are of a round nature but they have an opening from the base of the nostril toward the sides of the nose tip. Fig. 1 shows a diagram of the tip of a dog's nose. (There is only the tip of a dog's nose needed to portray him. The rest of his 'nose' is his muzzle which I show within the later examples.) You can see that when a basic colour is applied in Fig. 2, followed by the shadows and then the highlights in Fig. 3 and 4, it looks credible. All we need to know is the basic foundation of the nose structure and we can build on this by studying the varying sizes, shapes, colours and different angles that we may come across.

When I begin to draw a dog's nose I draw the outer edge of the nose tip and then I place the nostrils by working out how far they are from the top or bottom and how far in from the sides. I take note of the size of the nostrils compared to the whole of the nose tip. All that I need to do then is to apply the tonal values and colours as shown in the diagram. The last part of portraying the nose is where I add a light colour – often white or light grey – to the top above the nostrils, which gives the dog his 'wet nose' look and also gives it a three-dimensional and life-like look.

Paws

Paws are relatively easy to illustrate when you understand the bone structure. An x-ray of a dog's paw can look extremely similar to the bone structure of a human hand. All paws have a main pad, which I would equate to the ball of the human foot. Each paw has four 'toes' with a pad on the underside of each. They also have a 'thumb' known as a dew claw which is slightly higher up on the dog's leg. The covering of fur and hard leathery skin, however, make a dog's paw look very different to the human hand. As in ears – while you are drawing – the paws and toes are nearly always bigger than you think. Armed with my knowledge of the basic structure of a paw, and bearing in mind that it varies in size, shape, angle and 'furriness' from dog to dog, I approach the initial sketching of the paw by studying the reference picture and how big the paw is in relation to the dog's leg. I then take my pencil and lightly draw the basic outer shape of the whole paw. I then add the 'toes' while studying which ones appear to be bigger or smaller, or at an angle, to the others. I add the claws, including the dew claw to the inside leg a little further up, by drawing small curves which usually comes to a point.

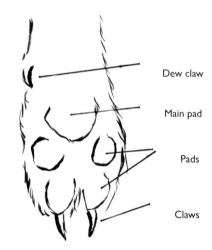

Dew claw

Main pad

Pads

Claws

34

Fur

Portraying fur varies in difficulty depending on which type of fur it is – long, short, coarse, soft, straight or curly. I often struggle with very 'messy' fur but cope easily with long shiny fur. Everybody will have their comfort zones or non-comfort zones. Here is a very basic build up to a fairly long fur, similar to the black fur shown earlier in the observation chapter, which I have decided to portray as a tan colour.

In this demonstration I have made a few initial marks with a soft burnt umber (dark brown) pastel. I have imagined the flow and where the shadows would be. I have indicated roughly the direction of the fur and where it alters. This will roughly indicate the shadows beneath the fur.

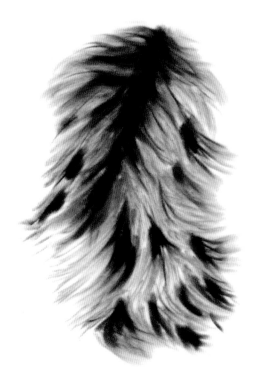

Next, I used a raw sienna (or orange) hard pastel to 'fill in' the spaces in between the burnt umber marks. Still working in the direction of the fur I used the top corner and the full length corner of the pastel stick to achieve different types of marks. Messy fur is quite random so there's no point in trying to be too precise.

I then applied a white soft pastel using bold marks in the centre of each 'bend' in the fur. This is where the light would reflect and I would call these bits 'the reflections'. It is about working in the highlights.

Next, I used the point of a sharp white pastel pencil to sweep through the 'reflections'. I place the pencil in the orange colour above the reflection, moving in the direction of the fur I drew a single line straight through to the colour beyond the reflection. I repeated this a few times to drag the white in to the orange, which lends itself to producing an image of fur strands that are shiny. I also draw, with the same pencil in the same way, through the shadows always following the fur direction. This really made the fur look life like. This demonstration is just to show the basics of how to begin to achieve an image of fur. I may keep working more highlights by adding more 'reflections' with a white pastel stick and drawing through with a sharp pencil until I'm happy with it.

At the final stage I used a graphite pencil, in the same way as I used the pastel pencil, through the highlights and shadows, to really 'polish it up'.

Methods of Creating an Initial Sketch

The most difficult part of drawing your dog portrait is making the first mark on the blank piece of paper. There are different methods of making an initial sketch including freehand, tracing, the grid method, and using a tablet. Some portrait artists use a projector to transfer their photographs to paper or canvas. However, they are quite expensive. It has been suggested that some of the old masters from centuries ago used what can only be described as 'predecessors of the modern day camera' to aid them with the composition and initial sketching.Known as a camera obscura, this early camera is best described a large box, or a room even, that was dark inside, with a small hole placed on one side. When external light passes through the hole it projects the image from outside to a wall inside the box/room. The artist simply drew around the projected image, albeit it was upside down! It is a controversial issue because people have argued that the great artists of the past would never 'cheat' but

I believe, whether they did or they didn't, that it is simply a way of using and utilising what was to hand.

Freehand Sketch Demonstration

On the following pages is a quick example of the progression of a portrait before moving on to a more detailed exercise.

Meet Joey. He's a black and white Border Collie. I created his portrait at a dog show in front of an audience so I had to sketch him freehand. Look at the photograph as if the dog were a flat object (in a two-dimensional way). Find the shapes that build his form. I saw an oval shape and a circle. The large oval would indicate the top of his head right down to where his fur on his neck falls over his collar. The smaller circle inside indicates his muzzle and begins just below his eyes

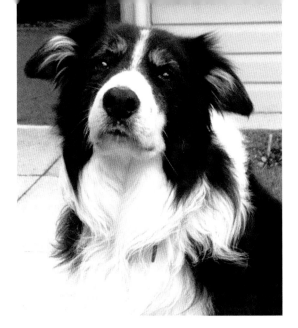
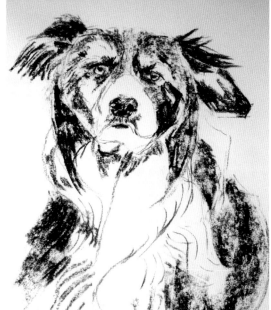

and the bottom of the circle sweeps along the bottom of his mouth. You may not see the same shapes as I do. That doesn't matter. All you have to do is roughly draw the shapes that you do see, whether it be squares, triangles, circles or heart shapes. The point is that when you start drawing the shapes you will then be able to work out how and where to place features such as the eyes, nose, mouth and ears. There are no strict rules on how you would begin a sketch, for instance, some people might decide to literally draw a cross through the reference photograph and work out how to place the different features from this. I prefer to use 'shapes'. Study in which direction his fur lies and where it falls and meets. Study the lighter and darker parts of both the white and the black fur. Look for the 'whitest' part of the photograph and then look for the 'blackest'. From which direction is the light coming? I'd say it's coming from the top and the right of the photo (the dog's left). His muzzle is causing

grey shadows on his white fur just under his chin. These are the things you will look for when starting your portrait. I will describe this in far more detail in the chapter on how to draw freehand.

This is the initial sketch on slightly grained acid-free, off-white watercolour paper. Using a charcoal stick to sketch the initial shapes, as described above, I then 'scumbled' with the side of a soft black pastel stick to loosely suggest the darker parts of Joey and also a rough direction of the fur.

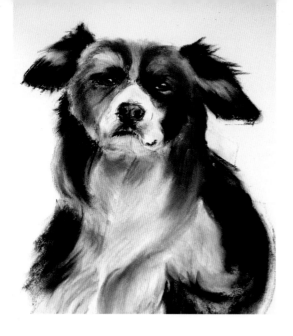

I used a white pastel stick to suggest the white fur on the dog's muzzle and bib. I blended some of the black into the white to begin suggesting where the shadows fall. I used raw sienna (reddish brown) for his irises and, using a black pastel pencil, I created his pupils, making sure I left a bit of the white paper showing through to create the reflection in his eyes. Getting this bit right is probably one of the most important parts of the portrait. As in a human, a dog's soul and personality can be seen within the eyes.

On the right-hand page is Joey completed. I have put in the fur details, using sharp pastel pencils, corrected his nose and eyes and I have given him his whiskers. I put in a warm mid brown as a background but I kept it plain to avoid detracting from his flowing fur. I faded out his white fur loosely near the base of the picture. If you look a little more closely you can see the basic principles that I used for the fur demonstration in the previous chapter.

"To practise any art, no matter how well or badly, is a way to make your soul grow. So do it."
– KURT VONNEGUT

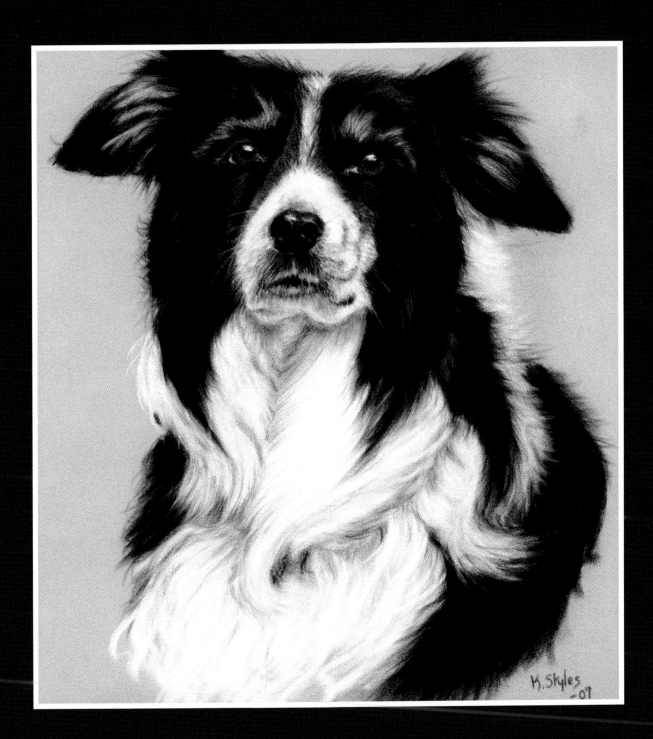

K.Styles
-07

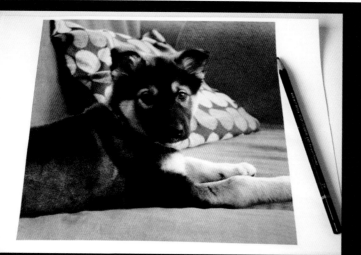

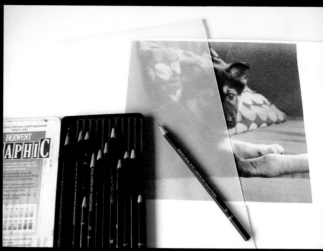

Tracing Method

If you have a printed paper copy of a photograph that is the size that you wish your finished picture to be you could trace the outlines from the print and simply transfer them to your chosen paper. Some people might say this is cheating but I don't think it is. The tracing method is actually a good way to get to know the object you wish to draw until you're confident enough to draw it freehand. I find drawing freehand to be more satisfying, but there is no reason not to use the tracing method if it gives you the results you love and you enjoy the process. Artist's carbon paper is similar to tracing paper. You arrange the carbon paper over your choice of artist's paper, then arrange the reference picture on top. As you draw around the outline of the reference image with a sharp pencil, the carbon is transferred directly to the artist's paper beneath. Using tracing paper instead is more economical.

You will need a sheet of transparent tracing paper, a reference picture (which will be the same size as the finished picture) and an HB pencil or an H pencil.

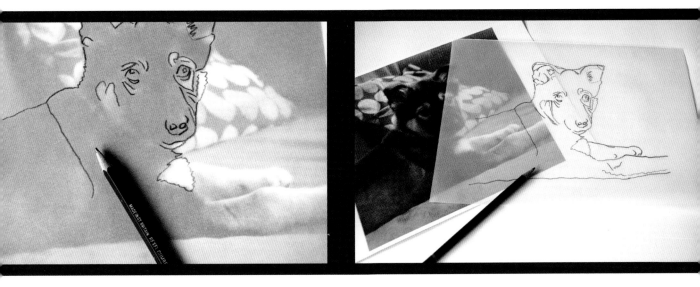

For the purpose of making the image clearer in the book, and as a demonstration only, I am using a 2B pencil here rather than the HB pencil I would usually use. Arrange the tracing paper on top of the printed image of the dog. Working on a flat surface, hold the paper steady and draw around the outline of the dog. Try to make the eyes and nose accurate as this will save time trying to correct them later. Draw in any lines that you think will help guide you, such as the point where any light-coloured fur meets dark, any

folds in the skin, and any muscle definition. Trace any part of the picture that you think will help you to 'colour in' your subject.

Next, flip the tracing paper over and onto a sheet of white scrap paper and with a soft B pencil (I'm using a 7B) draw, using pressure, over the lines that you see through the paper. Scribble over the traced lines quite thickly because this is the graphite that will transfer to the portrait paper.

43

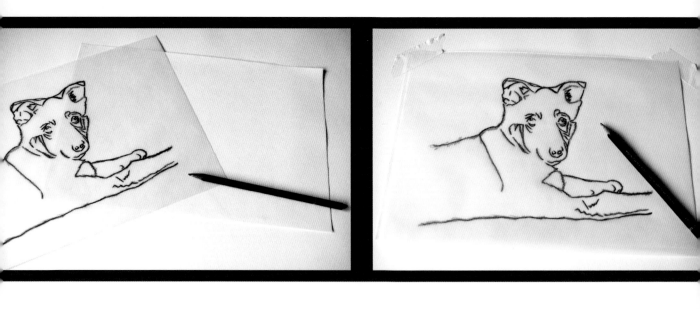

Turn the tracing back over so that the original tracing is on top. Arrange it carefully on to your chosen portrait paper.

I secure the 'portrait' paper to the work surface with a little masking tape on the top right-hand corner and then secure the tracing paper at the top left with another piece of masking tape. This allows you to lift the tracing paper to check that the carbon is transferring so that you can see the transferred image clearly enough. Using an H pencil (I'm using a 2H), carefully draw over the lines to transfer the graphite on the reverse side to the portrait paper.

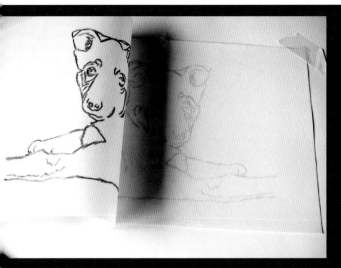

I tend to carefully lift my tracing paper about half way to make sure it's transferring well. You can see here how the image has transferred on to the portrait paper. Don't worry too much if the transfer has caused indentations in the portrait paper, you can mostly disguise them with clever use of your pastels and pencils later on. This is especially true if you are using velour paper. If you are using other pastel papers, as a rule of thumb, the smoother the paper, the more pressure you can exert in the second tracing. It's trial and error.

Once, as an experiment, I drew a sketch of a dog and then duplicated it by tracing. I gave the copy to my husband to 'colour in' while I began my sketch. When we had finished the difference between the two finished portraits was astounding. (My husband Michael would be the first to admit that he is no 'artist'.) This told us a couple of things. Michael hadn't used his powers of observation to determine the lights, darks and medium tones and how they all fitted together. He also said he struggled with the details in the eyes and nose because he had never really 'observed' them. The experiment also tells us that even if you create the perfect initial sketch it can, and sometimes does in my experience, still go wrong. This doesn't matter because it can always be corrected to a piece that you are ultimately happy with.

To begin with the placement of colour I placed a little poppy red into her ears using the side of the tip of my pencil. I chose a poppy red, rather than, say, a soft pink because it is a mid-range colour that will

help me determine lighter and darker tones around it. Any similar type of colour could be used as it can be slightly changed later on when I am applying further details around her ears. Also, because she is a cute little puppy I decided that a fun colour to begin with would be nice. Why not? Knowing where to begin when starting to place colours can be one of the most difficult challenges of the whole exercise. There was no particular reason why I started at the ears. I then took a dark grey pencil and decided to sweep around the dark areas of the image. Note how I'm holding my pencil so that it's at a very shallow angle to the paper and is held quite loosely. This gives the picture a flowing feel and allows me to sweep the colour in the direction of the fur. I often choose not to begin with pencils but every portrait is different and I approach them all in different ways. The reason I began with a pencil here is because I wasn't sure exactly where to start so using a pencil enabled me to begin more slowly than usual and on a smaller scale until I became more confidant with my applications. I will look more closely at colour in the next chapter, so am not going to give it too much attention here at this point.

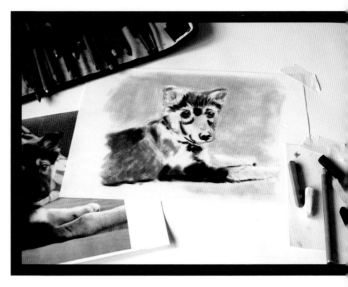

After blocking in the remainder of the fur I have almost covered the whole image with colour. Blocking in is the term for applying relatively larger areas of colour after the initial sketch is finished. The fur and other details will be applied on top of this later on. Here I have used blacks and greys but only quite lightly so that I can build the colour up gradually.

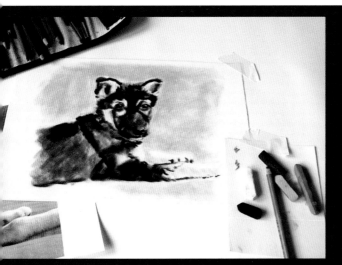 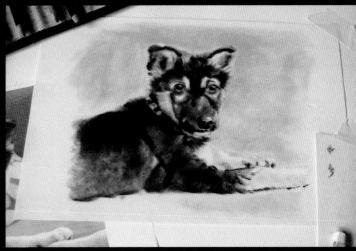

At this point in the illustration I realised that the fur was a different texture to any I'd illustrated before. Husky puppy fur has a curly, fine, downy, dark undercoat with suggestions of a fine white overcoat at the beginnings of its growth. I needed to portray this accurately while still being able to capture her true 'puppiness'.

I took my blending sponge stick and began to press it lightly on to the paper and, instead of making strokes, I pressed and 'wiggled' it into the pastel, all around her body. This movement gives little random circles that suggest the curly undercoat. I then took a sharp white pastel pencil and, using the point, made tiny marks over this to suggest the growing overcoat. I finished by adding more black around the face and using a 2B graphite pencil I finalised the fur on her front leg, added a few whiskers, ear detailing and the rest of the fur. I did this by using the pencil point and drawing small strokes. Obviously the whiskers were longer strokes.

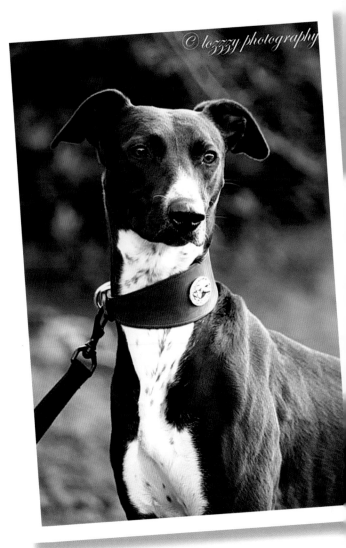

Grid Method

Another way to create an accurate image is to use a method I've called 'gridding'. If you are new to dog portraits this method is a great way to learn about proportions and how to capture the subject's form. I use this method if I've struggled to get the freehand attempt right first time. For this method you need a photograph of the animal in the pose you want to capture. I will show you how to create a grid and then how to use the grid to create an initial sketch. In this exercise, I explain the process of building up colours and layers as well as adding details and completing the finished piece.

I've made a printed paper copy of a photograph, that was digitally stored, onto A4 printer paper. If I want to work from a physical photograph then I either print one onto photographic paper or take it, on a USB stick, to a high street store that offers a print facility, or to my local supermarket, which offers the same service. I recommend this because it's an inexpensive service and saves your own printer ink.

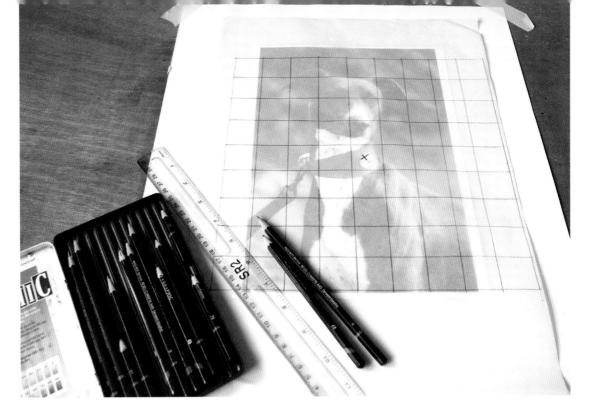

I have a grid already prepared on tracing paper that I position on top of my reference picture. If this is the first time you have ever used this method you could draw a grid directly on to the image you wish to copy. It will take longer but it will be easier to see the details. Otherwise create a grid on tracing paper using 3 cm (1¹/₄ in) squares. This size of square works well for my purposes, but you could make the squares any size you like. I placed the printed image of the dog directly on the blank sheet of velour. This is to gauge the size of the image in relation to my paper size. The printed image is a size and composition that I am happy with so when I begin to make a corresponding grid on my velour paper I will make the squares 3 cm (1¹/₄ in), the same as my ready-made grid. If, however, I decided I wanted the finished portrait to be larger than the printed

reference I would draw my corresponding grid on the velour paper at say, 3.5 or 4 cm squares (1¹/₂ or 1³/₄ in) to result in a larger finished portrait. This method is a very handy way to scale up pictures.

If you look closely you will notice that I have placed an X in the centre square. This is a starter point for the grid I'm about to draw on to my paper. It also gives a reference for counting across or up and down.

(There have been times when I have drawn the nose in to the wrong square and I've produced a very strange looking animal!)

You will need a soft graphite pencil (I'm using a 6B) or a pastel pencil, a rule, and of course, your sheet of paper or canvas. It's a good idea to fix your paper to the work surface at this point.

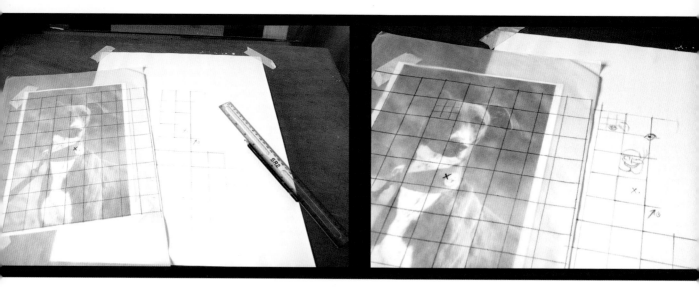

I have carefully fixed my reference picture to the ready-made grid with masking tape to keep it in place. Beginning in the centre of my paper I have drawn a 3 cm (1¹/₄ in) square and marked it with an X. This is the starting point to create more 3 cm (1¹/₄ in) squares around it. I am aiming to only draw grid lines that will more or less be contained within the form of the dog. This is because it's not possible to completely erase the grid in the background area, due to the nature of velour paper. If I took my grid to the edges of the paper I would have to cover the unwanted grid lines with a solid, heavy background. I prefer to have the choice of a light, or even no, background. If you are using a paper from which markings can be erased then you can draw your grid over as much of the paper as you like. Toward the 'edges' of the dog I have made some 'half' or part lines, which guide me where to draw. Only use the lightest pressure with your pencil for your grid and you will find that they will be easier to cover with pastels or to

erase. Note that I've exaggerated the depth of tone on the gridlines for the purpose of this book only.

When the grid is in place you can begin to create the initial sketch by following the lines of the dog in relation to the grid guidelines. I tend to begin by placing the eyes and nose. If you look at one particular square within the reference picture you should find it quite easy to transfer whatever is in that square into the corresponding square on the paper. I noted that the nose is mostly within the square above the starting square (the one with an X). I used the top line of the square to guide me how to place the detail correctly. If you look carefully you can see that I have created another grid inside the square that falls over the dog's right eye. This is to help me place the eye even more accurately than I felt I was achieving. You can do this at other points on the dog (or grid) if you become unsure of your progress in any particular area. The next part that I sketched was the collar because it has a continuous

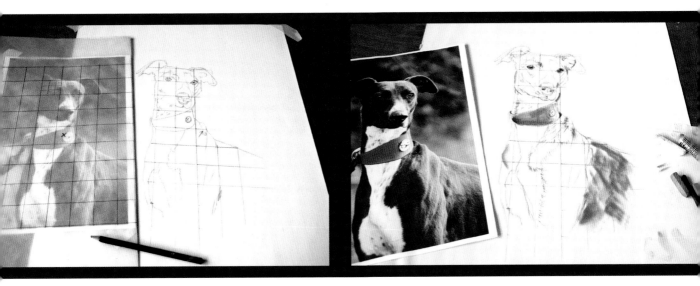

line that crosses three squares. Notice that the base of the collar dips just below the grid on two squares and the top of the collar from the left halfway down a gridline and sweeps up to the top corner of the next square. This is the basic principle of drawing by using a grid and as you draw more parts of the dog you can use those parts as further references for other applications in your sketch.

I continued with the ears next. I drew the right ear (the higher one on the reference) incorrectly because I hadn't created enough gridlines. I then followed different colourings on the fur and sketched the body outline. I finished by lightly marking any dark shadows or muscle definitions. Her back and side are not too precise because I wanted to 'fade out' this part of her portrait later.

I don't have a formula for adding colour because every portrait I make is different. With this portrait I felt that if I started with a mid-range colour then it will be easier to pick out the lighter and darker tones in the rest of the picture. I decided to start at the collar and the eyes because they match. I have defined some of the fur direction on her chest, too. I have suggested a few marks around the face where the sunlight catches her fur with the same raw sienna pastel stick. This is the beginnings of the blocking in process I mentioned earlier.

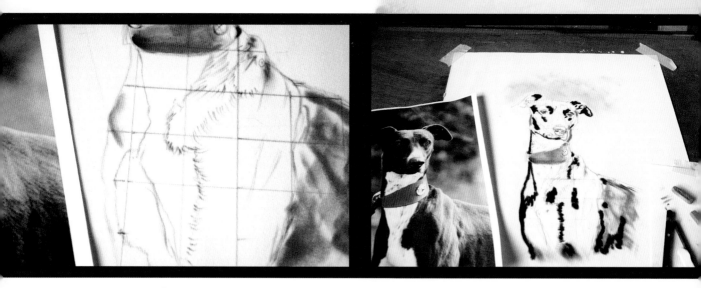

It's all about experimentation at this point and the more suggestions of colour, tone and fur direction that you offer and try, then the more you are learning about the dog you are portraying. It's like a snowball effect. You find yourself becoming aware of the shadows, the highlights, the direction of the light and so on. It's an enjoyable journey if you let it be.

Next, I blocked in some of the darkest areas with a very dark brown (burnt umber) pastel and also put some white on her chest, neck and nose. I have also suggested colour around the top of her head. I have altered her nose a little with a graphite pencil as it was looking a little 'bent'.

As I pointed out earlier all of the portraits that I create are different and on this one I am already considering what type of a background I might make. I will probably use the background in the photograph as inspiration because it is a very balanced scene.

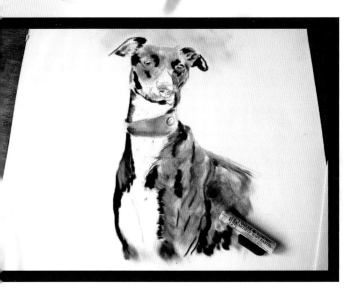

Next I took a raw umber (mid-brown) pastel and loosely applied it to the body where she is brown. I say 'loosely' because I still need to be able to see where the muscle definitions and highlights and shadows are. I have exaggerated the ripples on her left side, with the edge of the raw umber pastel stick, which are highlighted by the sunlight on the photograph. I then studied my photograph again. If you want to really work out where the highlights and/or shadows are in your photograph a good tip is to squint at it. Try it. It really does work. Squinting draws out the extremes and enables you to see the lightest or darkest parts of the picture. I do this very often.

I've noted that there are mid-grey tones on the right-hand side of the face and on the left shoulder and chest at the front. This is mainly where the shadow falls. Using a cool grey, I have suggested where these shadows will be. It doesn't have to be too precise at this stage. Apart from her muzzle the portrait is almost all covered so this is the point

that I bring in my blending sponge. I could use my fingers but I want to really learn about, and begin suggesting, the direction of her fur on her body and face. Using the blending stick will make faint marks within the pastel that I have already set down and I will be able to use those marks as a guide when applying pencil marks later. It will take longer but I will learn more detail. If I were to use my fingers at this stage I would be just pressing the pastel in to the paper and not really giving myself a real guide to the fur direction.

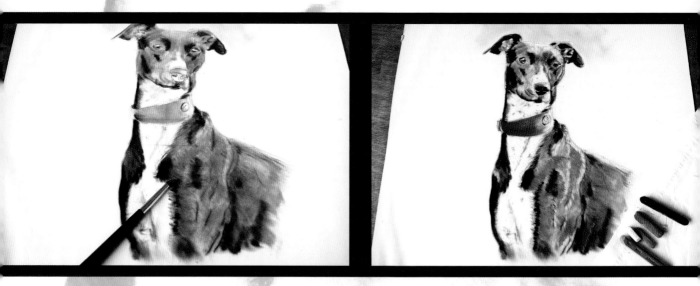

After using my blending sponge stick the picture doesn't look as though it's moved forward much but it has enabled me to establish the directions of the fur in different areas. At the same time I noticed some minor amendments that I may need to deal with later in the process. I finished the blending with my fingers by 'pushing' the colours into any remaining areas of the paper that weren't yet covered. Next, I built up another layer and hopefully began to cover some of the remaining grids.

I've now started to use a black pastel stick to suggest the deepest shadows around the dog. I picked them out by squinting at my reference picture. I have also added a mid grey to represent the 'less deep' shadows. A few marks of mid brown to the areas on Jazz that catch the sunlight really begin to bring her to life at this point. I've added white highlights to the small folds in her fur at the side of her body and to the top of her head. I then rub this in using my index finger. I do this in the direction of her fur. This blends the whole 'story' of her fur together as a base for you to work your pencils on for the finer details. I have also added the warm mid brown to her collar and mixed it in with the raw sienna.

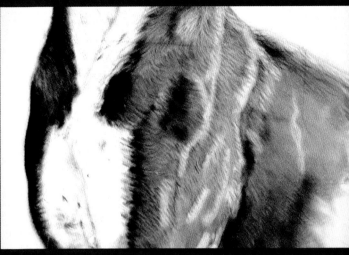

I have now swept over the area of her body that catches the sunlight with a warm grey and added even more white marks to help me suggest the muscle definition around her shoulder and back. These white marks will help guide me when I work with the pencils.

Beginning with a very dark grey pencil, I have begun to suggest fur with small feathery strokes. I hold my pencil near the top and apply short quick strokes in the fur direction and I draw them over the highlights as well as over the 'body' lowlights. I tend to move around the dog as a whole rather than concentrating on one specific part for too long. I believe that this helps unify the whole picture.

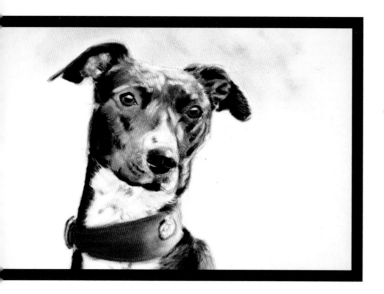

I have used a raw sienna pencil over the original burnt sienna to give the eyes depth and I have defined their outline with a black pencil. They're still not quite right but the beauty of pastels is that you can keep working into the image until you're happy with it. Using the same pencil I have drawn lines near the edge of the collar to suggest the stitching.

When I move to the pencil stage I always have my pastel sticks nearby and am constantly adding highlights – as you can see on the face. Even when I have applied an amount of fur detail I might still go over it with a coloured pastel stick if I want to change something. The detail can still be seen through the extra layer if you don't apply it too heavily.

Next, I use a sharp white pencil to accentuate the short fur even more. The type of marks you make depend on where and how you hold the pencil. Try different ways and look at the marks each 'experiment' makes.

I also use the white pencil to blend. The marks that you make with the white pencil will not always appear to be white (they can appear grey because the pencil is dragging through the colour that's already there but you will find you are still defining the fur). I clean the tip of my pencil every few strokes or so with my fingers. If you make little white strokes in between some of the dark strokes you have already made it will really begin to bring out the definition of the fur.

I decided that I hadn't made the body 'brown' enough so I lightly swept a very dark brown soft pastel all around the area where she is covered with brown fur including her head and face.

I can still see where the highlights were, under the brown I have just applied, so I have gone over them all with touches of white pastel ready to work in again. I also lost some of the mid-grey tones when I added more brown so I'll apply those again later. I have suggested 'spots' on her white fur using a sharp black pencil. The portrait is near to completion and it's now just a matter of working and re-working the highlights and fur definition.

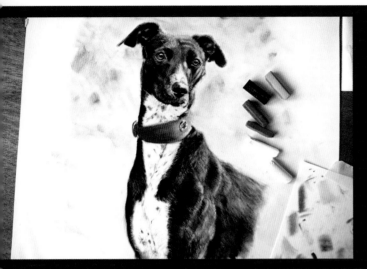

At this late stage I have decided that, again, she needs to be a little darker so I am going to work some black in around the edges and within the folds of her skin where her fur is brown. As I pointed out earlier all of the portraits that I create are different and on this one I am considering what type of a background I might make. I have decided to use the background in the photograph as inspiration because it is a very balanced scene. I applied the background by gently scumbling a selection of blue, greens and greys around her while following the general balance of the colours in the original photograph.

I used a black pastel pencil to slim down the collar ring and the collar stud to make them look more realistic. A few small random black marks inside the white bits of the stud gives the impression of texture.

Opposite is the finished portrait complete with a quick spray of fixative (or in my case hairspray) and a heavy card mount ready to be framed.

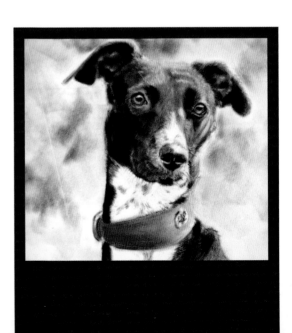

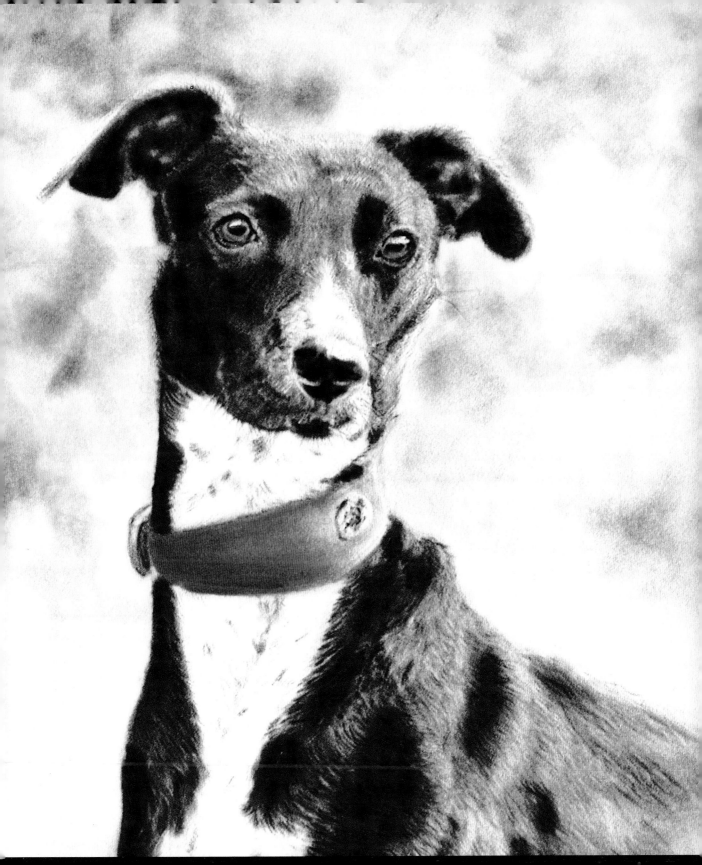

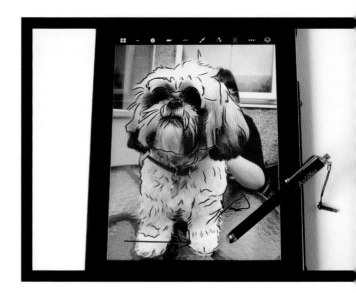

Using a Tablet App for Initial Sketching

If you own a tablet then you have more options to create an initial sketch. Whatever type of device you have, there are plenty of different drawing or sketching apps to choose from. Many are free, so it's worth trying out a few different ones to find out which one you are comfortable with.

Such apps usually have a tutorial to help you navigate your way around. To get started, open the app and choose a digital photograph or reference picture.

Create a 'layer'. This is similar to adding a tracing paper sheet over the top of your photograph. Your sketch will be on the 'tracing paper' layer and you will be able to remove the reference photograph after you have traced over it. Initially it appears as if you are 'drawing' directly onto your photograph, on screen, but what you are actually doing is drawing on the invisible 'layer' that you created. Sketching apps provide you with options for different drawing tools, colours and opacities. There is a facility option to undo your last action

on all of the apps. I have indicated with an arrow to a small button near the bottom that this is the 'eraser' tool for this particular app.

When drawing on a tablet, you can use your finger, or you can purchase a special 'pen' that is specifically designed for sketching on tablets. Such pens are inexpensive and after testing one, I found that using my finger is just as accurate as using the pen. The pen is by no means a completely precise method of sketching, in fact, it can be quite clumsy, but it is still a good way of creating the general form and marking where the eyes, ears, nose and other important features are. Using your index finger, or pen, sketch around the image as if you were drawing it through tracing paper.

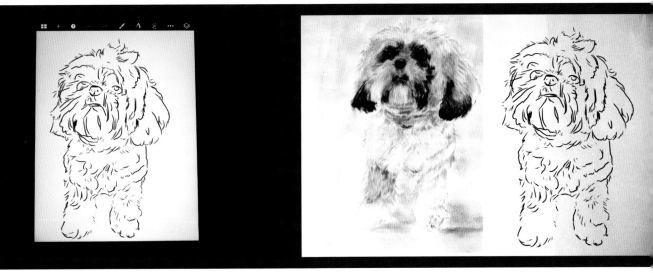

This is a finished initial sketch, on a tablet, of Bettie, a cute little Shih Tzu. It looks a little scary at this stage but once she has colour she'll begin to take form as the beautiful dog she is. Although I printed her initial sketch on A4 printer paper I transferred the drawing on to A3 velour. I've placed the A4 sheet of paper, which shows the initial sketch, next to her so that you can get a better idea of the dimensions and size. Using the original photograph for reference I blocked in the different tones, colours and shadows.

If you want to produce a digital portrait of your subject, rather than a traditional paper study, all you have to do is create yet another layer, choose which brushes and colours you want to use and then 'colour in'. I would use the same basic principles as if I was creating a portrait on paper. I would use a broad brush, with a low opacity, to block in tonal values to begin with. I would then add more layers of colour and tone. I would follow this by choosing finer 'pencil' options to sketch in details. The great thing about creating a digital sketch is that you can undo any features that you dislike and then simply redo them. It's a very good way to learn about colour, tone and form without having to use up your pastels, pencils and paper. When you are happy with your finished digital sketch all you have to do is remove the first two layers that you created, which are your original photograph and your sketch. Simply delete the layers that you don't want and you'll be left with your digital illustration. Digital artwork can be applied to any means of printing, such as canvas, t-shirts, bags, or coasters, to name but a few. Some commercial artists work solely in the digital medium.

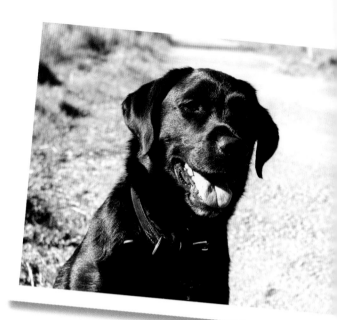

Starting to Sketch Freehand

The following portrait is illustrated 'freehand'. Drawing freehand may seem scary but really it isn't. If I make a sketch and it doesn't go as I would like, which is often, I call it a practice piece. Now I will show you how I created the initial sketch, coloured it in, applied details and then created a background. The method that I use can be applied to any subject, whether it's a cat, dog, elephant, bunch of flowers or a landscape.

Meet Jack. He's a black male Labrador. This is the photograph that I have decided to use to draw the portrait. I took a few snaps of him and, after consultations with the owner, decided that this was the best shot to use. The photograph was a little bit dark on the left side so, for purposes of making out his form, I used a photo-editing programme to crop the photograph and also to lighten it a little.

Jack was a very willing model, which was great, but because it was a sunny day the shadows were deepened in the shaded parts of his body and face. I chose Jack as a subject because he is all black and further on in this book I have chosen an all-white dog to demonstrate. What I hope to show is that whatever the colour of your subject you will still have to use the same thought processes to create a credible portrait by using not only certain colours but choosing the subtle (or radical) tonal differences to build its form. You may be surprised at just how little

'black' goes into an all-black dog and how little 'white' goes into an all white dog.

The first thing I do when I decide to use a particular photograph is to study it for a few minutes. I look for the darkest areas, the lightest, and the tones in between. The longer you study a photograph the more you will begin to see parts of the 'form' that you may not have noticed at first. I imagine how it will look on my paper and where I will fade the body out and I work out how I will illustrate the chest fur. This is all part of the 'composition' process. I have already decided to leave the collar out of the image so I will have to use some artistic licence on his chest fur. The experience that I have gained over the years will allow me to 'guess' how his fur falls on his chest.

In the early days, when I wasn't as confident, I would take more photos of the dog's chest, if that was possible, or I would find an image of a similar dog from another source and use that as a reference.

In many dog portraits I may have had four or five different photographs for one finished picture. I might use one for the pose, another for the colours, and yet others to pick out features that may not be immediately obvious in the initial photographs.

It's important to prepare. This is an important stage because it will give you more confidence about what you are about to create.

To begin with I am going to create a sketch on inexpensive paper. It will probably take about half an hour or so and it's time well spent because if it goes wrong then I've only wasted a sheet of cheap paper. I haven't lost the half hour because that's the learning process that I get to keep forever.

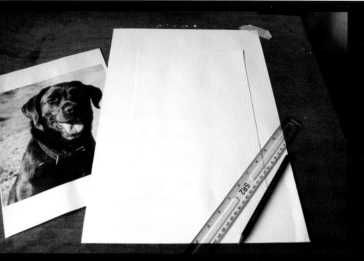

I have cut a scrap of paper to the same size as the frame that I intend to use, which is 40 x 30 cm (16 x 12 in). Inside the frame will be a 5 cm (2 in) wide mount. I cut a second scrap of paper to 30 x 20 cm (12 x 8 in) and centre it on the initial rectangle that I cut out. The 'border' of the original paper that lies beneath represents the mount that will be positioned around the finished portrait. The 30 x 20 cm (12 x 8 in) piece of paper on top is the size of the finished artwork and will help me to compose the drawing inside its boundaries. There is a bit of guesswork involved but I can size the image to what I think it roughly should be before sending it to print. This means that I am working with a reference that is roughly the same size as that I wish to sketch. This will always be a little easier than trying to draw freehand from a different size reference photograph.

The first things I look for when viewing the reference photograph are shapes: look for circles, squares, triangles or ovals within the shape of the animal. If you look at the photograph in a two, rather than three, dimensional way it should be easier to pick out flat shapes. In this example I start by finding a large circle that indicates the face down to the muzzle. I then find another smaller circle to indicate where the nose sits. When I use circles (or any other shapes) in this way I find it always helps if I then draw a vertical and horizontal line through the centre. This helps me position other parts of the anatomy such as fur, eyes, nose and ears. I wouldn't usually draw directly on to my reference image but I've done so here to demonstrate my method.

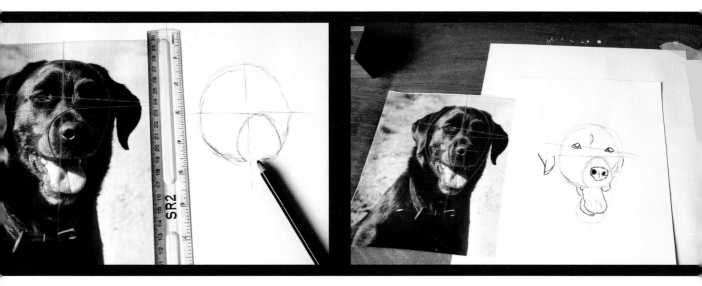

Paul Cezanne, a late 19th-century artist, said that the three fundamental shapes of all things are the cone, the sphere and cylinder. I also use squares, triangles and any other shape I think I can see.

I look at my reference photograph checking for other shapes in relation to the first and second circle. Using a rule as a guide I draw a horizontal line across the centre of the circle. This will further help me place other details like the eyes. I draw a second line diagonally across the circle, using the original horizontal line as a guide to help me place it correctly, through one eye to the other. Then I can place his eyes on the diagonal line. As you sketch the eyes be aware of the shape and relative size and relationship to each other. Check the distance between the eyes. Does it match the photo? If you're not sure, and your reference is roughly the size that you are drawing, then measure it. As you add more shapes and lines for reference you'll really begin to learn about the shape and form that you are creating.

I roughly sketch the shapes that I have 'discovered' on to my practice paper. It doesn't need to be precise at this stage because I'm using this method to learn about my subject. I made a large oval shape around the outside of the face and a much smaller circle around the bottom of the muzzle; this circle goes through the tongue. I place the tongue by taking note of the distances from my reference lines. As the sketch builds up the features become easier to place because you'll have filled in more details and have more information to guide you. For example, the bottom of his right ear is almost level with the bottom of his nose. I began to sketch the base of his ear but I made it too small at first. I measured the distance from the original circle (around his face) along the horizontal line (across the circle) to find out how far the ear stands proud of the head. Using what I have already drawn I can then place other features in relation to each other.

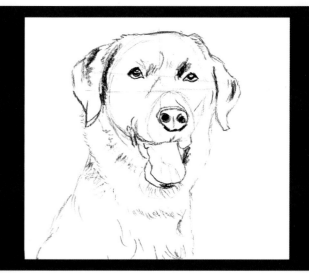

I add some fur direction and shading at this point and am fairly happy with the finished rough sketch. You can see here that he is beginning to look three dimensional. I have used a soft 6B graphite pencil, holding the pencil flat to the paper, rather than using the pencil point, so that my sketching is 'loose' and free flowing. This makes the initial sketching more enjoyable because I am not worrying about making mistakes – I am simply discovering the nature of the form that I am creating by loosely and boldly sketching rather than 'drawing'. It should be a very relaxing experience. No worrying allowed! I used a black pastel stick to scribble in some of the shadings. You don't have to be too precise at this point as you can make alterations as you go along. A piece of artwork owes as much to being an optical 'illusion' as it does to being a 'photographic' engineered piece of art. Now that I am confident that I can sketch Jack I will repeat this exercise on velour paper. I will raise the nose a little, too, because I have noticed that I have placed it a little too far away from the eyes.

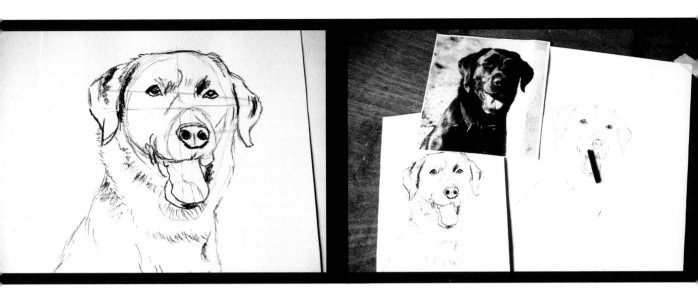

Following the same principle as for the practice sketch I repeated the exercise on velour paper using a thin charcoal stick to keeps the illustration fluid. A pencil is fine to use but, again, hold it flat to the paper and make sweeping lines rather than trying to be too precise.

We are ready to begin applying colour and tones at this point.

Colouring

To begin the colouring process here I am using a black 'hard' pastel stick, using the point, which is worn. I have marked the darkest parts of the dog's face, ears and nose as well as determining in which direction the fur falls on the body. I have also added white to the lightest parts of the face. This will help me work out where the medium tones will go. I have also placed the pupils omitting colouring a tiny area, which will be the eye 'flecks'.

time while you create the portrait. Drawing the direction of the fur is one of the most important parts of the process. On the chest a dog's fur almost always changes direction at a central point toward the middle lower chest and often around the top of its front legs. Short-haired dogs, especially Bull Terriers or Greyhounds, offer good examples of this.

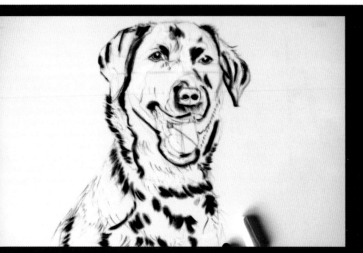 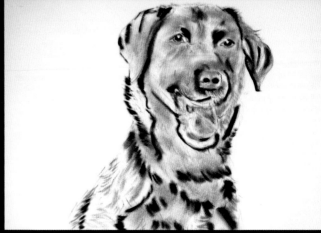

In my years of observing dogs I've noticed that the fur grows in the same direction in different parts of the body no matter what type of dog it is. On the brow of the face it grows upward and away from the nose, it changes direction near the insides of the eyes. It grows downward from the nose to the mouth. Study this in your photograph and on your dog and keep this in mind all of the

Using a pink pastel I have suggested his tongue colour and I have used a purple in the shaded part of his tongue. When I say 'to suggest' I mean just that. It doesn't have to be precisely like it is on the photograph. That would be too fiddly and demanding. The beauty of working with pastels is that you can go over something you decide you don't like.

Using a mid grey soft pastel I have lightly shaded in around the face and the bits of fur that I had not yet covered. This helps me to search for the medium tonal values as I go along. I press harder with the pastel stick (or use a slightly darker shade) where the darker tones need to be. All of the time I am bearing in mind the direction of his fur.

I will correct the shape of his eyes later on with a pastel pencil. The process from beginning this colour stage has taken me approximately 30 minutes. It is still at a very early stage and I estimate that this particular portrait will take about 6 working hours in total.

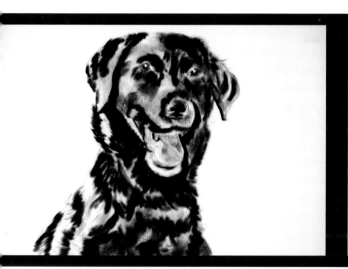

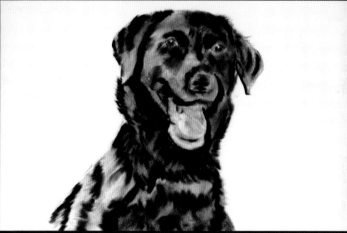

I have now added a lot more black pastel. When I really study the deepest areas in the photograph, even in the shadows of his face and fur, I can see that those areas are not actually completely black. By studying your photograph you can make out that there are, even inside the shadows, relatively lighter and darker areas. I have placed a little colour in to his eyes using a raw sienna pastel stick.

Using my fingers I have blended the black, white and grey together. It looks a bit flat and clumsy at the moment but it gives a good base to begin working out details. This is now at the stage that I call 'covered'. Some artists call this the 'ugly stage'. The whole image is now filled in.

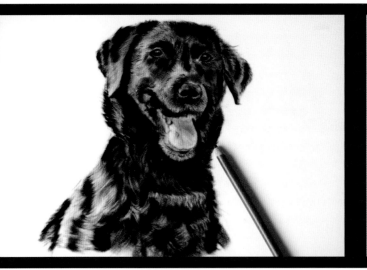 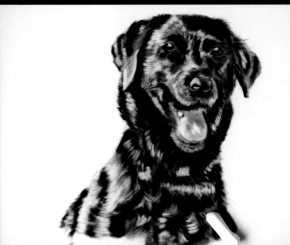

Blending

Usually at this point I would use my blending stick to work out the beginning of the details of the fur but this time I decided to use a black pastel pencil instead. You can use any tool you prefer. All you are doing is learning about where the fur is going, where the light is catching it and what is going on in his shaded parts. I've swept the pencil around the whole body and face staying with the direction of the fur and the fur changes. I have used shorter marks on his face where his fur is very short and I have used longer strokes in the fur on his chest. I have gone over the white parts as well, with my black pencil, in the same way. You can see the fur beginning to develop. I have also added a touch of raw sienna to the side of his mouth, so I can suggest his gums, and in his eyes. This whole process took around 10 minutes.

On some portraits I find I use blending quite a lot and in other portraits I tend to only use the blending a little. If you need to blend at any time during your portrait creation then just blend away.

To continue with the blending process I have added a lot more white by using a soft pastel stick, again, to seek out the highlights. I've marked his tooth, near the back of his tongue, and the 'fleck' in his eyes, which I will rework later on. Creating a portrait isn't just a matter of getting everything into the right place first time. It is a learning process throughout. You will notice that I have also added white to the darkest shaded areas. This is to create the form that is within the shadows as I mentioned earlier. Although it may still look a little clumsy at this stage I will then blend this in with my sponge and follow this by applying white pastel pencil over the blending. I have left his collar out of the portrait so I have to guess which way the fur is falling. Once I have decided, though, I have to stick with it

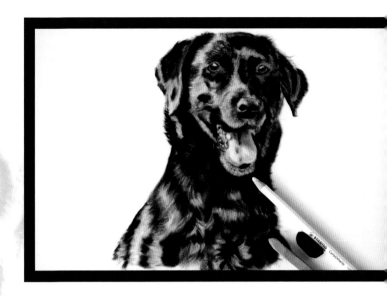

parts of his fur I used the tip of the pastel stick and pressed quite hard. I then swept the side of the pastel stick gently, in broader strokes, over the areas that are in the shade. You will still be able to make out the highlights underneath.

I am also adding a few mid tones with a mid cool grey. I will add this mainly in the shaded areas. I've added a bit more raw sienna in to his eyes. I've noted that I will need to make his left eye slightly smaller and I will do this with pencil later on. I've also suggested, with a few small white dots, the reflections along his gum line. I will repeat the blending, and adding highlights and lowlights, a few times more. Both the high and low lights that I apply will get smaller each time and the pencils will come in to play much more.

because it's quite difficult, although not impossible, to change direction of fur once it has been set down.

I use the blending stick over the new highlights sweeping small strokes in the direction of the fur. I repeat this with a white pastel pencil to begin to create the detail in the fur. I return to a black soft pastel and darken the darkest areas again which will begin to make a starker contrast with the highlights. In the small very dark

Applying Details

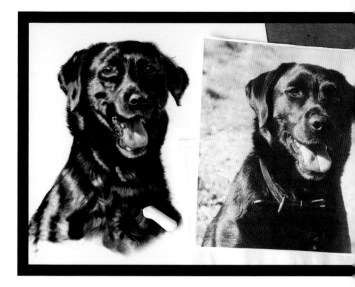

I have added even more highlights here but they are smaller. I have decided to change the direction of his fur (against my own advice earlier) toward the base of his neck. I've popped two white diagonal marks, directly below the bottom of his mouth and toward the left on his lower neck, with a white pastel stick ready to be blended in my chosen direction with a pencil. I have applied these latest highlights to the parts where the light from the sun hits him. Next, I will use both a very sharp black and a very sharp white pastel pencil to begin creating fur detail. Try holding the pencil in different ways and see what kind of marks you can achieve. I tend to experiment even when I am creating an actual portrait for a client. Always sweep your pencil in the direction of the fur. You do not need to actually put in every single hair. Just a few suggestions here and there will create an illusion of 'all over' fur. When the portrait is finished the viewer's eyes will do the rest.

Have fun. The marks that you make with the white pencil don't always appear as white, because the pencil will drag some of the black in the direction that the pencil is moving. This is another type of blending, and is still moving toward creating finer detail. While you're sweeping the white pencil over black, the colour it leaves can appear as grey allowing it to add to the depth of the finished subject. Do the same with the black pencil and enjoy what you are creating.

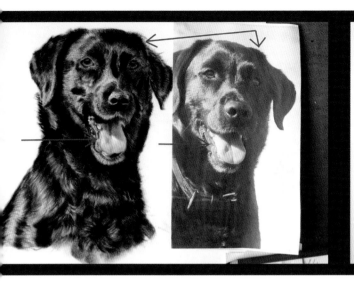

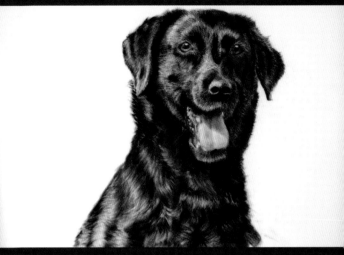

Here I have indicated a couple of areas that I need to correct. The tongue is too thin and I haven't got the top of his left ear quite right. I also decided I had him looking a bit too slim over all so I 'extended' him around his neck and shoulders by adding approximately half a centimetre, with a pastel stick, at each side. I have applied small black marks on to his muzzle to suggest his 'whisker holes'. I did this with a pastel stick, rather than a pencil, because it's much less precise and I find that it keeps the picture 'free'. By 'free' I mean that the portrait is not a piece of precise engineering. If you can imagine a picture of, say, a house created by a draughtsman, each line measured and accurate, then you would have a nice picture but if the same house was sketched loosely and by free hand then that would be, in my opinion, a much more flowing piece of art. It would be more 'free'.

With the corrections made I used a white soft pastel to cover the line at the side of his tongue that I had drawn incorrectly until it was back in line with his tooth. I then studied the different colours that made up the tongue itself. I found white, pink, red, purple, grey and a tiny bit of black. A component of a piece may need to be studied on its own merit and its own peculiarities applied to give credibility to the whole picture.

I have also looked at his eyes again. The colours that I applied in the eyes are raw sienna, yellow ochre, black, white, blue and a touch of red. The minute touch of red is to make the eyes look warmer. The devil is in the detail. I have drawn a black line inside his top eyelids, which have given them more depth and made them appear slightly smaller as they should be. I have added a few of his whiskers with a sharp white pencil. I then took a sharp black pencil and drew immediately next to the whiskers I had just drawn. This really helps give them a three-

73

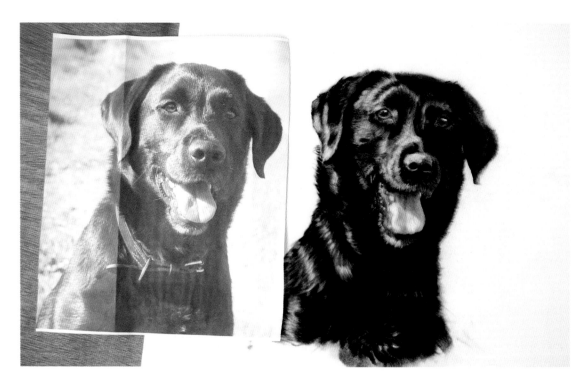

dimensional quality. Jack's portrait is not far off finished, but I like to add more black to the recesses of his fur and I will do some more blending with a black pencil especially at the top of his head where the highlights seem a little harsh. I also think about adding a little colour to his fur.

As I now look at the image as a whole, rather than focussing on details, I decide that he's not really dark enough. After all, he is supposed to be a very black dog. I check the balance of light and shade as a whole and then hone in to make sure I'm happy with the details. I also decide that I have made his nose too small. Using the flattened side of a soft black pastel stick I have lightly

swept around the parts of the image that are in the shade and then I applied more black in between the highlights created in the fur where the sun shines on him. I applied deepest black around his tongue and at the same time I made the whiskers on his chin (under his tongue) a bit smaller. I took a sharp black pencil and extended this action by dragging further in to the highlights from the black just applied, not just under his chin but around the whole image. Using a soft white stick I extended his nose by placing a white mark at the top and at the same time I also re worked his nostrils in to what I think is the correct position.

Backgrounds

At this stage I begin to experiment with some background colour because my paper is beginning to look a little dirty. A subtle background is best because you want the viewer to see the dog and not be overwhelmed by a busy or loud background. A good tip, if you have decided on a 'plain' background, is to lighten the shade, of whichever colour you have chosen, around the part of your subject that is darkest and vice versa. I do this by pressing the pastel to the paper harder where I want it to be a deeper shade and by hardly touching the paper at all where I want it to be lighter. Another way of achieving this is to add white and/or dark grey to your chosen colour. This creates an illusion of depth. I tend to stick to this rule most of the time and it works for me. I took my inspiration for this background from the portrait of Jazz earlier in the book. I did use a touch of black in the background this time but I used it very gently so as to not overwhelm the whole picture.

I selected a very pale grey soft pastel stick (but a hard pastel will work just as well) and using the side of the stick I have gently swept around the dog. I scumbled the greens, dark blue, yellow and black around the image until I was happy with it. I didn't take the background right to the edges of the paper because I want the whole thing quite 'loose' rather than regimented and 'perfect'. Besides, it will be covered with a mount. Remember, if you do go wrong you can always fix it.

Finishing Touches

I always concentrate on the whiskers and eyes at the end. I have used a blue pastel pencil to put a very tiny dot next to the highlights in his eyes. I have used yellow ochre to deepen the amber in his eyes, and then I added the tiniest touch of raw sienna to the corners of his eyes to really bring out their depth. Finally, I used the white pencil to put in the remaining whiskers. Hold your pencil firmly, press onto the image where you want the whisker to emanate from, and then sweep in one confident go. You don't have to be too accurate. Repeat this for however many whiskers you want to apply. Dogs don't just have whiskers coming from the muzzle, there are usually whiskers from the side of their 'cheeks' and above the eyes. I have used a black graphite pencil to indicate whiskers above the left eye.

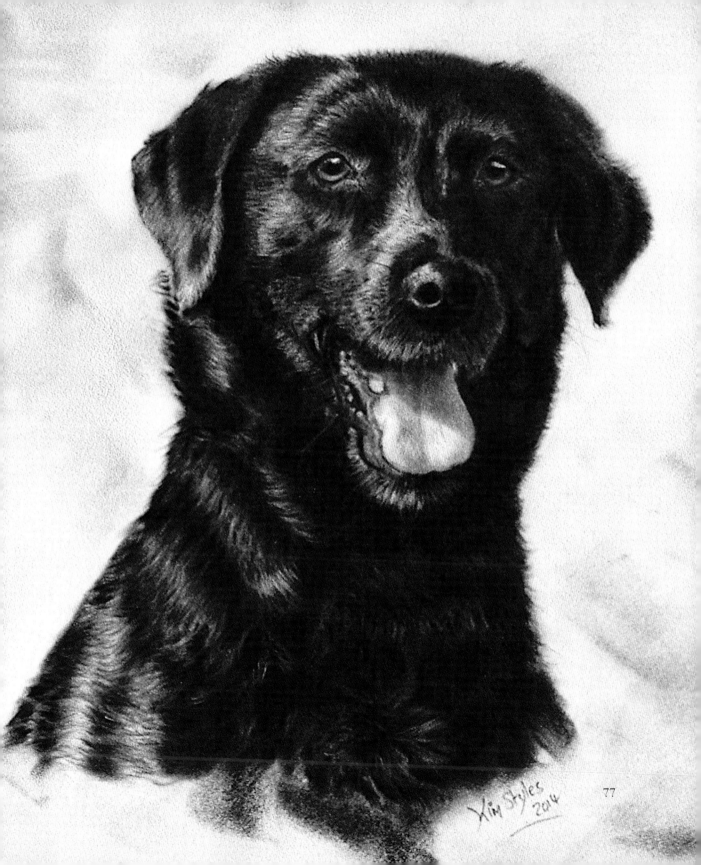

Kim Styles
2014

77

White Dog on White Paper

This example is Finnley, a white dog, which I will create on white paper. White on white is one of the most difficult artistic challenges. If you wish to portray a beige dog on beige paper, or even a black dog on black paper, you can follow the same principle that I use here.

Finnley was photographed indoors and in a conservatory so that there was enough light. The shot of him is good and clear so I am confident that we can create an accurate likeness of him. He has quite a lot of shadow on him but this will actually help me to determine his relative tonal values. I have cropped the original photograph so that I can print it onto A4 paper and will be able to work from that. I am working on 33 x 41 cm (13 x 16 in) velour-coated paper, and intend to apply a 5 cm (2 in) wide mount around the finished work. The finished portrait will fit a standard 33 x 30 cm (16 x 12 in) frame. I have decided to fade him out toward the back of his body and down toward the bottom of the picture, and concentrate the finer details on his face and chest. This composition is in my mind at this stage – it doesn't necessarily mean that it will actually happen. Think of the finished artwork as a desired end goal, but assess and review along the way and know that if you end with something different to your initial ideas that it will be fine.

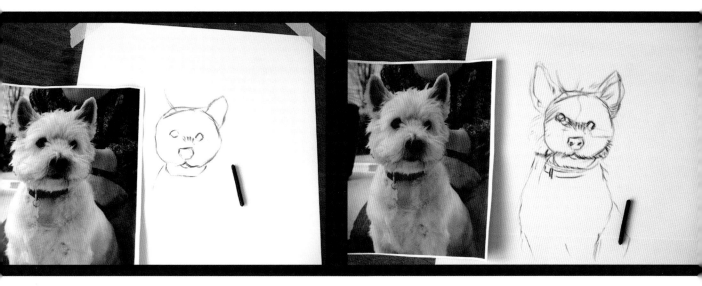

I'm using a charcoal stick for my initial sketch but a soft pencil will do. First, I sketch a circle for the main part of his face. I hardly apply any pressure, so that the lines that I am drawing are very faint, but for the purpose of this book I have actually used a lot of pressure so it is clear in the photograph. I have given an indication of where his shoulders begin and I have placed his eyes and nose by working out where they sit in relation to the circle I have drawn. I have also indicated, roughly, where his ears are to be.

I realised that I had placed his eyes slightly incorrectly so I moved his right eye up a little and then checked with a ruler that I had placed both properly. After another adjustment I am happy that they are roughly where they are supposed to be. They can be altered again later, if necessary. I also measured the ears and realised I had made them a little too small and that the left one was too 'flat'. I had placed it slightly

below where it should be and the ear tip was pointing sideward rather than straight up. I corrected this and he instantly looked better! I have also made him a little bit too slim too so I decide to 'fatten' his body a little, too. I am constantly making adjustments at this stage until I am happy to continue. Using the same charcoal stick I begin to look at his fur directions and roughly sketch in his body and place a suggestion of his collar by working out where it falls in relation to the muzzle and chest. It all looks a bit odd at this stage, especially with the dark circle still showing, but it should gradually grow in to a credible image of a cute little fluffy dog.

"Do not fear mistakes – there are none"
– MILES DAVID.

79

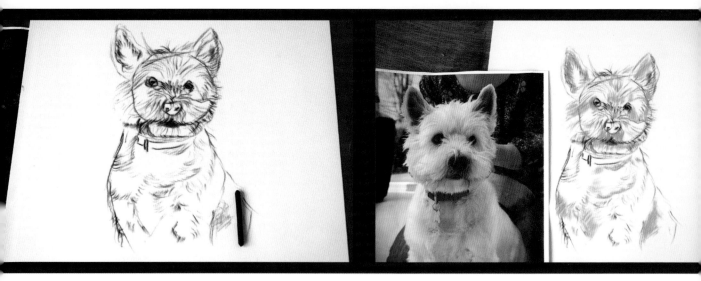

Still using the charcoal stick I loosely begin to sketch in the directions of Finnley's fur. I do this around his ears, face and body. I look for what I think are the darkest parts to guide me. It still looks quite odd at this point.

Now it's time to add colour. I apply a light warm grey in small blocks and strokes in the areas of shadow. What I am doing is actually drawing in the shadows in between the fur while working out in which way the fur lies and how long or short it is in different areas. I am also learning where the fur changes direction. You could think of this method of drawing as working in reverse or inside out. Note the shadow around and under his muzzle, and also behind his foreleg, where I will begin to fade him out. During the whole process of creating a portrait I am

actually learning, or employing my highly honed observation skills, right through to the end. I am adding the light warm grey tone to anywhere in the portrait that suggests medium or darker shades and I will use them in the next few steps to guide me when I am applying more tones. You may have noticed that I have now made his body a bit on the chunky side. Looking at the left side of the picture near the collar I realise that I need to bring that in a little. Also, I have a line shooting out of the top of his head where I initially placed his right ear incorrectly. His left ear has a bulge where I got that wrong, too. I will correct all of these errors later on. I may consider applying a background to do this. I am also hoping that the application of more tones will begin to hide the heavy circle.

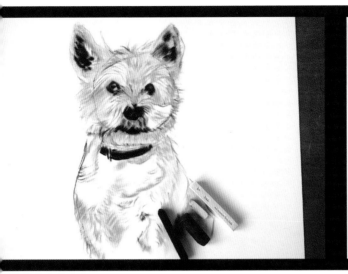

Still working in mid tones I have applied a pale cool grey around the areas of the fur that are next to the brightest highlights that are caused by the light falling on to him. This will make the top highlights that I apply later on stand out more. I have suggested his collar using burnt umber and placed a little umber into his ears for the shadows. Using black, I cover his nose and suggested the base of his mouth. I 'flung' a couple of small black lines from his nose that will eventually help to define the fur around that area and where you can see the outer edges of his nose through the fur. Still working in reverse, here. You can almost see the pale coloured fur developing even though I haven't actually used any 'white' pastel yet. The pale fur that you are beginning to see on this dog is actually the paper.

Next, I have used a mid dark cool grey for the darkest areas in the shorter fur on the chest. I'm applying small marks that will enable me to use lighter tones in between the marks to begin to bring out the texture of the fur. I then place pink in the ears using 'fur strokes', which will indicate where strands of fur fall within the inside of the ear. I added a touch of pink near his eyes and in the middle of his chest. If ever you're going to see pink within a dog it will most usually be inside the ears, around the eyes and nose and sometimes in the mid chest area. This generally applies to paler dogs. You would be amazed at just how many colours can be used in portraying a white dog.

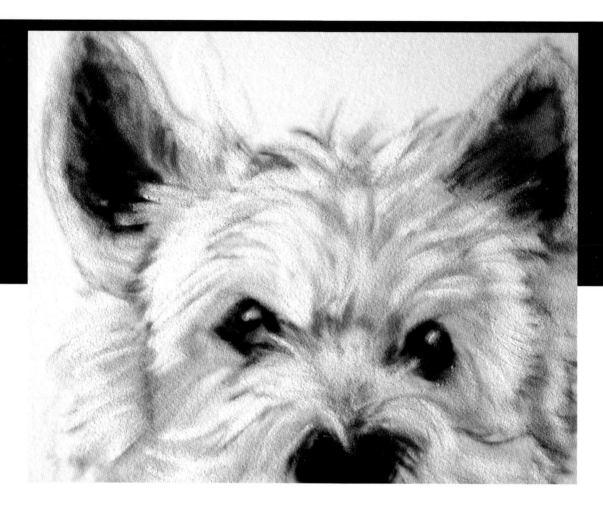

I then apply white. This is not because he is a white dog as such, but because I am deciding where the light bounces off him and which parts of the portrait will eventually be the lightest. Most of this white application will be worked in later with pencils and blending. I have also used the white to block out the errors I made earlier because I found that they were distracting me. I just pressed and rubbed over the offending marks with the pastel stick. I am still aiming to cover the big dark circle around his face as I work. After the white I used a yellow ochre to

begin to suggest his truer colour by very lightly scumbling around his chest and face. He is actually off white. While sketching fur directions under his mouth and around his face and chest I am still experimenting as I work and there is still a great amount of application and adjustment to go at this stage. Next, I will blend all over the image, with my fingers, so as to fill it in completely. This means that any paper is no longer showing through. After blending you will notice that the image now looks quite dull and flat.

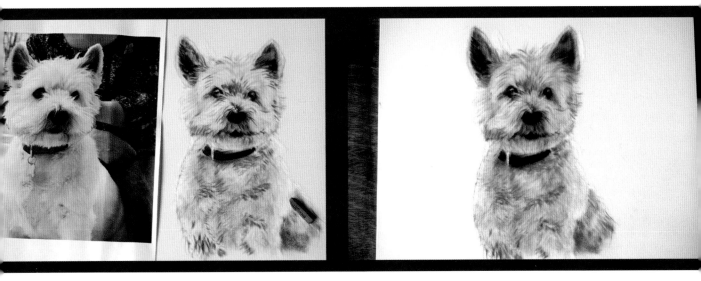

Next, I have chosen a mid tone (dark warm grey) hard pastel and, using the corner, I have placed shadows in the fur on the top of his nose and between his eyes. I have also worked some into the inside of his ears to suggest darker shadows that will be in between the lighter coloured fur that I will apply later. I have placed a few small marks (almost dots) around his chest fur, especially where it changes direction. Finally, I used the side of the pastel stick to gently place some shadow around his front and where the back of his body fades out. He still looks quite dark at the moment but he will become lighter as we go on. Now is the point where I get my blending stick out.

Working in short, fairly gentle strokes, and always following the direction of the fur, I work the pastel into the paper and blend the shadows and highlights into each other. I have my reference photo very close by and I am looking at it almost more than I am looking at my subject while I am doing this.

All the while I am noticing much more about where the fur starts and finishes, where it meets, where it changes direction, where it is shorter or longer and where the smaller shadows are within the fur. It's a therapeutic part of the process for me and it's probably one of the most important because I am still learning about my subject. In effect I am 'zoning in' toward the details.

Next I switch to pencils. You could, if you wish, carry on until the finish by using pastel sticks if you wanted a 'looser' portrait. My style is to produce a highly detailed finish so I begin to use pencils at this stage. First I will use a dark brown or black pencil to begin to define around the eyes and nose – and again I will 'fling' a few short dark lines from his nose, and his eyes, to indicate shadows in between the strands of fur.

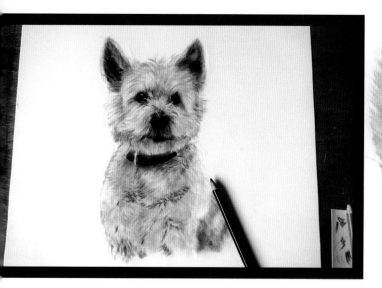

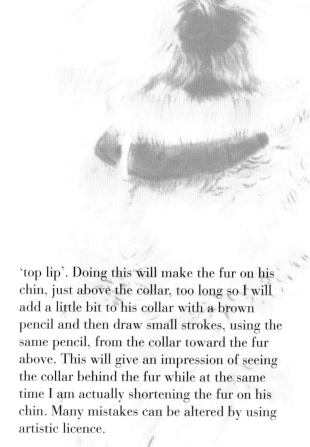

Using a mid brown pastel pencil I place his irises, which are difficult to see on the photograph but I noticed his eyes were brown when I met him, and I suggested 'behind the fur' inside his ears. This is to suggest the skin colour on the inside of his ears which will have small pieces of pale coloured 'ear fur' placed over it later. The reason that I'm not using pink for this is because the inside of his ears are in shadow. Still using the mid brown I also draw in some fur around his nose and muzzle. I am imagining where the lighter strands of fur will go and I am drawing inside (in between) them.

Next, using a sharp black pencil I create his 'eye liner' by drawing carefully around the outer rims of his socket and I also places lines from his eyes toward the fur around his nose. This begins to show the fur's form and begins to give a three-dimensional feel. I have also made his lower nose slightly larger because I realised that I have made his nose too small and have left too much of a gap between the base of his nose and his

'top lip'. Doing this will make the fur on his chin, just above the collar, too long so I will add a little bit to his collar with a brown pencil and then draw small strokes, using the same pencil, from the collar toward the fur above. This will give an impression of seeing the collar behind the fur while at the same time I am actually shortening the fur on his chin. Many mistakes can be altered by using artistic licence.

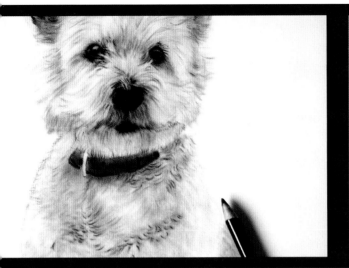

Using the same black pencil, I apply short marks in between the lighter strokes of fur on his chest. I actually draw the marks in the small shadows that were created earlier with the pastel sticks. Again you can begin to see the fur taking on a three-dimensional form. I also use the same method that I used around the eyes and collar by sketching a few 'fur strands' from his nose into the surrounding fur to suggest the area 'in between'.

I now bring in a newly sharpened white pastel pencil and, following the directions of his fur, I will begin to define it. This can be done quite randomly but working between the shadows will really bring the fur out. However, I will work the white pencil over the shadows as well as on the 'white' fur, which will suggest fur inside the shadows, too.. Finnley is now beginning to look really soft and authentic.

You can see how the fur has developed. My pencil was quite sharp when I began this process. It took me around 10 minutes to do this and I wore the point down completely by the time I had finished this stage. I also used a small piece of soft black pastel to slightly darken inside the ears in between the white fur that I had just drawn. I also darkened the nose and nose area. The beauty of using pastels is that even when you have drawn in details you can still go over them lightly with another colour pastel but still retain the details underneath. I am deciding whether to use a lightly applied yellow ochre pastel, at this stage, to reduce the 'chalkiness' that using too much white causes. Finnley is almost at the finishing stages, it's just a matter of adjustments and re-working him in places until I am happy with him.

After adding yellow ochre all over Finnley, and making him look too yellow, firstly I toned this down by using a raw sienna (reddish-brown) pencil to define fur around his nose, muzzle, ears and parts of his chest. I have then added 'chunks' of white on any parts of him that I decide is to be highlights. I will work these marks in with white and light grey pencils. I may repeat this stage two or three times until I feel that I have achieved the softness I am looking for. Each time that I do add highlights, in this way, I make them smaller each time. Using a very sharp white pencil, literally drag the point through the new highlights in the direction of the fur. Rather than actually 'drawing white lines' you are blending the highlights through the fur. While blending the highlights with a white pastel pencil I also had to hand a black and a brown pastel pencil. In between the strokes that I have made with the white pencil I would use the black and the brown pencil to put strokes in between some of the whites. This really

helps to make the fur strands stand out.

I spend quite a while at this point highlighting, blending and bringing the fur out. Every now and again I step back and look at the whole image to make sure it is looking even. In other words I am making sure there are no 'flat' or 'large chalky bits' that I have missed. I work over the whole dog moving from the fur to the ears, the nose, the muzzle and body. This way, I am, hopefully, giving a balanced treatment. I have reworked the white flecks in his eyes to make them brighter and I have added a touch of Prussian blue (although any blue will do) to each side of the fleck to represent reflection of the sky. If I want minute details within the fur I will often use a 6B, or similar, graphite pencil. You really can experiment as you're going along because if you do make a mistake you can just go over it, so don't be afraid to try different things. On this occasion I used a sharp 4B pencil to pick out the fur around his eyes, nose and muzzle. Using very gentle sweeps

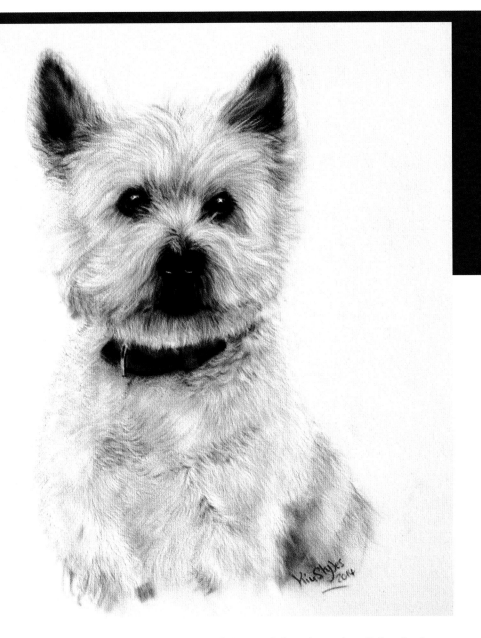

I also define the chest fur a little more by applying the marks within the white strands of fur. After an enjoyable 10 minutes of this I decide the picture is finished. You could spend two weeks thinking that this needs a bit of this and that, but when I decide the piece is finished I get it mounted and/or framed as soon as possible so that I'm not tempted to keep re-working it. It's so easy to spoil it if you do.

Mounting Your Work

If you want to fit your latest masterpiece with a complementary mount (or matt board) your local art shop can often do this for you at a small cost. The application of a surrounding mount gives the finished portrait a professional look. If you are painting for yourself or family and friends it's probably more cost effective to get your mount made at your local art shop. Get it cut so that it will fit a standard frame size if possible. That way you don't need to incur the expense of a custom-made frame. Often you can buy a frame that is supplied with a ready-made mount. My husband makes mounts for my paintings by using a selection of mount boards, a special 'Logan bevel cutter', a straight-edge cutter and a special rule that he bought on the internet. You will need a self-healing cutting mat, which protects your table, as well as your blades, and can be bought from any good craft store. Self-cutting mats come in a range of sizes. An A3 size is perfectly adequate. In my experience the more expensive versions

don't seem to be any better than the cheaper versions.

You will need a mount (mat) cutting system, if you are to make your own mounts. This is a rule that is made in such a way that allows a cutter to be attached to it. This enables you to cut a clean straight line. A roll of masking tape and very sharp pencil are essential too. You can use a sturdy craft knife for straight cuts instead of a dedicated cutter but the purpose-made cutter is a much safer option. You will also need a bevel cutter to achieve a bevel edge to the inside of the mount.

The final item that you will need is a sheet of mount (or mat) board. I normally supply a back board with my finished portraits. It helps protect the portrait and mount during transit and, as they are mostly produced acid free, it also prevents eventual damage to the finished portrait. It has been said that using non acid-free materials can eventually cause yellowing of the picture.

Back board is available at art stores.

It is bigger, thicker and stronger than mount board.

Using a sturdy straight-edge rule, and a very sharp pencil, measure and mark the size of the back board that you wish to cut. Cut out using the rule and cutter, or your craft knife, by following the guide lines that you have drawn. When you have done this you may want to lightly smooth any rough edges with a little sandpaper (glasspaper). The mount board that I chose to surround my portrait of Jazz, (see earlier in the book), is an off-white tone called Royal blue twilight. This is because it has minute blue speckles that gives it a clean crisp shade that complements most of the portraits that I do without appearing too 'yellow'.

Mark out on the reverse side of the mount board. Work out how to get the optimal amount of boards that you want while leaving the least amount of wastage. Measure the outside dimensions that you wish to use. In this case my finished portrait will be fitted into a 40 x 30 cm (16 x 12 in) standard frame size so this is the size we will measure. If you have already cut a back board to your size then it's easier to just place the backboard on to the mount board and draw around it.

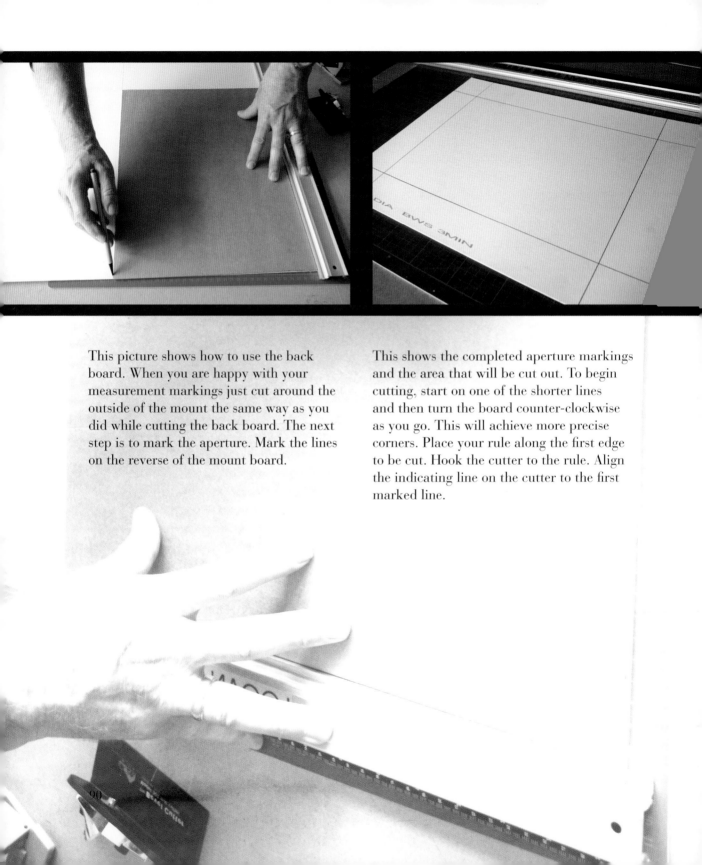

This picture shows how to use the back board. When you are happy with your measurement markings just cut around the outside of the mount the same way as you did while cutting the back board. The next step is to mark the aperture. Mark the lines on the reverse of the mount board.

This shows the completed aperture markings and the area that will be cut out. To begin cutting, start on one of the shorter lines and then turn the board counter-clockwise as you go. This will achieve more precise corners. Place your rule along the first edge to be cut. Hook the cutter to the rule. Align the indicating line on the cutter to the first marked line.

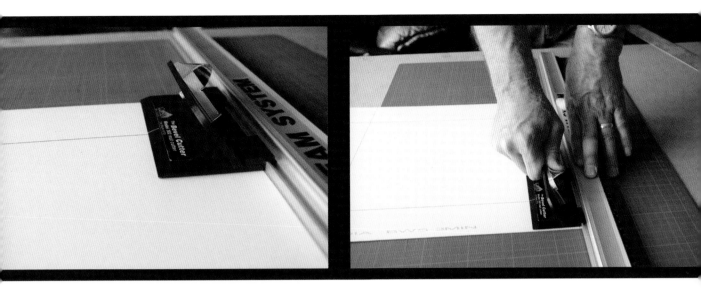

Run the cutter smoothly along the line and stop when the indicator line on the cutter is level with the opposite line.

Lift the retractable blade on the cutter when you finish the first cut. Then lift the rule and the cutter off the board. Turn the board counter-clockwise and repeat the process for the second, third and final cut.

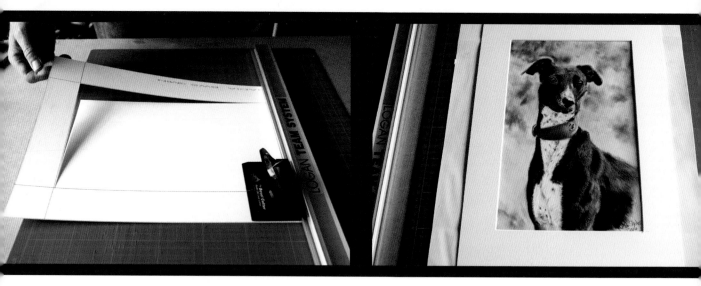

When you have finished cutting all four sides flick the aperture out of the mount with your fingers. Try the mount over the portrait and position it how you want it to look.

Trim any surplus paper from around the mount. Carefully draw on to the paper with a pencil around the edges of the mount. When you have done this move the mount to one side.

With a rule, measure approximately 2.5 cm (1 in) (in this case) from the top line down toward the portrait and draw another line parallel to it. If you are making a smaller mount then you might measure 2 cm (¾ in) or 1.25 cm (½ in) instead. Do this to create a lip with the paper to enable a masking tape hinge to attach the picture to the mount.

With your rule and craft knife, cut directly on the line that was drawn parallel to the top line. Cut just inside (1–2 mm) the other lines so that the portrait is slightly smaller than the mount.

You might be tempted to turn the picture and mount to the reverse side and tape all four edges of the paper to the mount. However, because of the nature of any paper, it mayeventually stretch and buckle slightly over time, so I recommend creating the tape hinge instead.

Framing

Align the portrait on the back of the mount and fix two, or three, small pieces of tape to the top. These are the hinges that attach the portrait directly to the mount board on the reverse side. When the picture is hinged make sure that the base of the picture is a millimetre or so just above the base of the mount. This is to allow any creases to drop out and allow the paper to stretch. Not fixing the picture here will ensure that the paper will not buckle after time. There is no need to fix the picture in any other place because the hinges will hold it firmly in place.

If you have decided to use backing board just arrange the mounted picture over it. It's now ready to be framed.

There are sets of standard-size frames available and I find it easier to tailor my portraits to fit these standard sizes. This means that I can offer my clients a finished picture, mounted, and to a standard frame size. The client then can purchase an off-the-shelf frame rather than going to the trouble, and expense, of having one custom made. Frames are inexpensive nowadays. Just choose one that complements the tones of the image, open it up from the back, place your mounted portrait the correct way up, fix it back together – whether you use your own backing board or not is up to you.

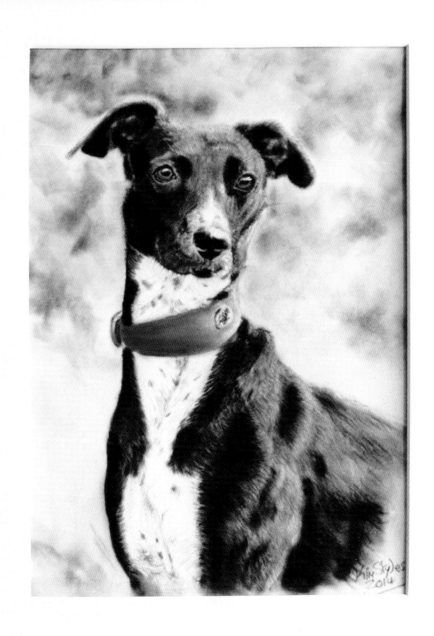

Acknowledgements

First and foremost, I would like to thank Alan Whiticker and the team at New Holland for inviting me to write this book.

Secondly, I would like to thank my husband Michael for his unending support, help and encouragement.

Thank you to my late dad, John, who encouraged me to draw from a very early age.

I would also like to thank Garry Newby, Andrea Parton, Tracy Wooffinden, Barry Andrew and Debbie Britton for their encouragement and belief in me as a commercial portrait artist during the early days.

Thank you to Amber, Kim and Hugo Sunderland for their help with photography and Laura Speed of Lozzzy Photography who took the perfect photograph for me to use in this book.

Thanks to Giselle and Steven Plummer, Aimee Harper, Jemma Whitford and Steve Fitzpatrick for allowing their beloved dogs to model for me.

And last, but not least, a big thank you to Dawn Wood and Lynda Watts for their help whenever I became 'stuck'.

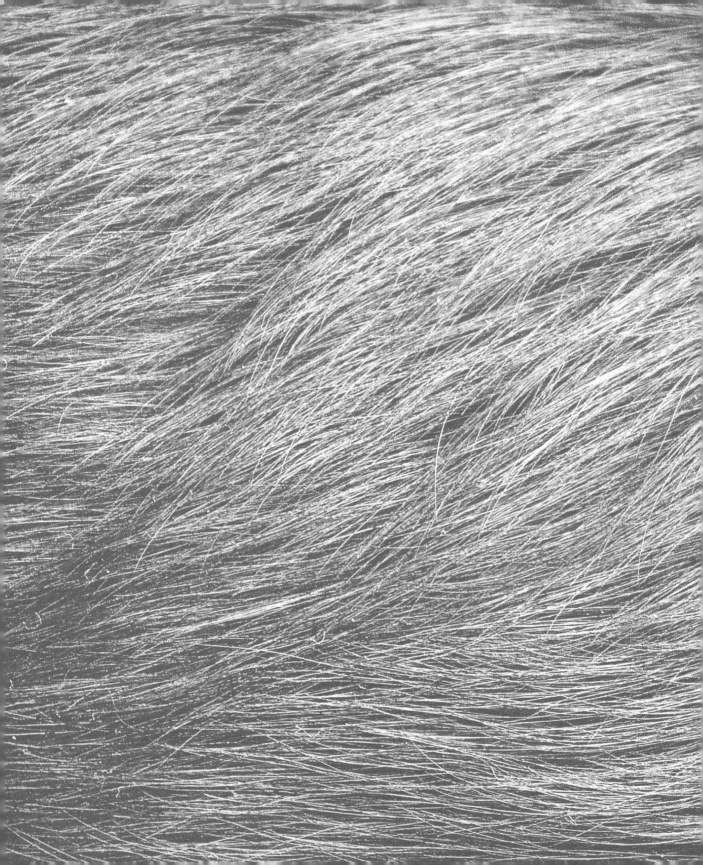